The Critique Handbook

A Sourcebook and Survival Guide

Kendall Buster and Paula Crawford

PEARSON

Prentice
Hall

UPPER SADDLE RIVER, NEW JERSEY 07458

Library of Congress Cataloging-in-Publication Data

Buster, Kendall.
 The critique handbook: a sourcebook and survival guide / Kendall Buster and Paula Crawford.
 p. cm.
 Includes index.
 ISBN 0-13-150544-0
 1. Art—Study and teaching (Higher)—Methodology. 2. Art criticism. 3. Peer review.
 I. Crawford, Paula. II. Title.

N345.B87 2007
701'.18071—dc22 2005056639

Editor-in-Chief: Sarah Touborg
Acquisitions Editor: Amber Mackey
Editorial Assistant: Keri Molinari
Marketing Manager: Brandy Dawson
Director of Production & Manufacturing: Barbara Kittle
Managing Editor: Lisa larkowski
Production Editor: Jean Lapidus
Indexer: Murray Fisher
Manufacturing Manager: Nick Sklitsis
Prepress & Manufacturing Buyer: Sherry Lewis
Cover Design: Kendall Buster & Paula Crawford
Cover Printer: Coral Graphics
Compositor: Integra–India
Printer/Binder: Courier/Westford

Pearson Education LTD. Pearson Education Australia PTY, Limited
Pearson Education Singapore, Pte. Ltd Pearson Education North Asia Ltd
Pearson Education, Canada, Ltd Pearson Educación de Mexico, S.A. de C.V.
Pearson Education—Japan Pearson Education Malaysia, Pte. Ltd

10 9 8 7 6 5 4 3 2 1
ISBN 0-13-150544-0

Contents

PREFACE

One can picture the art school critique as a small point, like a rest area, along the continuous line of a student's studio practice. It's a place to stop, check your direction, look at the map if necessary, clear the trash out of the car, and generally refresh yourself for the next leg of the journey. It is neither a destination, nor is it the path itself. But it can be useful, as a kind of systems check and place to reflect on the purpose and progress of your passage.

In the following pages, we have attempted to offer a variety of languages, vantage points, and practical structures for viewing and analyzing works of art. Conceding that there cannot be a single system for the evaluation of art, but rather a network of interlocking languages based on sometimes incompatible assumptions, we've isolated some of the larger spheres of influence in an attempt both to examine and connect them.

This book is derived from our own experiences both as students and as teachers of art and was motivated by the realization that there are no maps or guidebooks for the critique, as far as we know, that really parse and scrutinize this strange ritual with an eye to making participation in it useful and even illuminating. Indeed any good critique relies on a free flow of ideas as they run parallel to, in contradiction with, or are even embodied by works of art. We have structured our book to reflect this, with all of the inevitable overlaps and repetitions. Forgive us for this. If at times this book reads like a laundry list of options, it should be taken in the spirit of the kind of brainstorming that critiques themselves inspire when fresh eyes examine works of art.

The book is organized into two main sections. Section One, *Framing the Discussion*, consists of four chapters, which present ways to think about and discuss studio work. Ideas are presented on their own terms and through the imagining or reconstruction of critique situations. Section Two, *Having the Discussion*, examines the critique itself as a complex and dynamic discourse played out by human actors. It offers concrete advice on preparing for, engaging in, and getting the most out of art school critiques.

Acknowledgments

This book is a collaborative project in the fullest sense, born out of many conversations and experiences that the two of us have shared, first as art students and then as artists, teachers of art, and friends. While jointly conceived and written, this collaboration could not have been realized without our colleagues and students at the Corcoran College of Art and Design, George Mason University, and Virginia Commonwealth University, where much of the raw material was generated through our experiences in the studios and critique rooms. We have also drawn on our experiences as students at the San Francisco Art Institute, Yale University School of Art, and the Whitney Museum Independent Study Program.

We would particularly like to thank Siemon Allen, Jeffrey Brown, and Sophie and Jack Crawford-Brown for their infinite patience and support throughout every stage of the writing of this book. We are deeply grateful to Suzanne Carbonneau for her help, Ledelle Moe for her encouragement, Kris Dahl and Morton Brown for their salient advice, and to our fathers, Ralph Buster and John Crawford, for their unwavering belief in us.

INTRODUCTION: WHAT IS A CRITIQUE?

The words *critic, criticism, critical, criterion*, and *critique* all come down to us from a family of words in Greek that refer to judging, distinguishing, and selecting. While art professors often see the critique purely as a place for constructive evaluation, to many art students, the critique is synonymous with judgment day. True to its Greek origins, the critique is seen as the place of reckoning, where the classroom authority blesses or disparages an object in which the student has become personally invested. The professor's job is to give useful criticism, to deconstruct the object and evaluate its parts with an eye to offering the student practical solutions to perceived deficiencies. The student's role is to distance himself enough from the work so that he can constructively participate in its demise. This dichotomy of the evaluative and the judgmental, already inherent in the critique's linguistic history, sets up the predetermined conflict that is played out in the formal art school critique.

This ritual, which occurs in the artificial setting of a classroom art studio, among students and art faculty, often becomes an end in itself, a goal toward which each student's production is aimed. But the critique is not a singular goal or deadline. Rather, it is one of many, part of a series of cadences that partition the semester into sections of creative productivity. Thus, the critique is both a deadline and a marker of a perpetual beginning, a freeze-frame moment in the context of a continuous studio practice. In a sense, this is carried beyond art school into professional practice when the critique is replaced by the curator's studio visit (another ritual of judgment and selection), the subsequent exhibition, and finally the press review.

The idea that the critique is really a small marker in the larger continuity of an artist's practice allows both student and teacher to think of it as a useful tracking device rather than as a courtroom drama. It becomes a kind of cross-sectional look at an ongoing activity rather than a place where items are ranked. This favors process over product, the means over the end, and arguably a belief in a necessary fluidity between the artist, the creative act, and the possibilities of a particular final product.

Nevertheless, as useful as it is to frame it as such, the critique has traditionally operated as a proceeding, where work (and perhaps student) is judged within the often subjective parameters derived from a professor's own art school experiences, aesthetic principles, and even taste. This becomes easy to see, in intermediate and advanced studio classes, when several professors (or other art professionals) focus on a single work and begin to offer vastly different assessments. While this can be confusing to students, it at least sends the healthy message that the interpretation of art is subjective, and that often winners and losers alike don't necessarily deserve either the censure or the praise they receive. Indeed, the criteria themselves are fluid and contextualized within an historical and current network of conversations about art that occur between the works themselves and the critical voices that surround them.

Kendall Buster and Paula Crawford

SECTION ONE

Framing the Discussion

Chapter One

FORMAL MATTERS

CONSIDERING FORM

Form and Content

When a group of students walks into a critique, first reactions will vary. Some students will initially examine the works of art by looking for narrative content. They will ask, "What story does this image tell? What does that object make me think about when I see it?" Others will try to access a work through almost unconscious immediate reactions, "How does that painting make me feel?"

These seemingly natural responses are in fact the direct result of the way a work is put together—the formal operations of a work. Formal choices can support or undermine narratives, hide or foreground the mechanics and materiality of a work, emphasize or ignore its relation to history, and, in general, guide a viewer's reception of the work. And so we begin with formal matters and with the related terms *form* and *content*.

We are tempted to think of *form* simply as a container that holds *content*. But there is slippage between the two terms. Form can refer to the material delivery portion of a work, as in the physical *form* of a sculpture, but it also refers to a set of visual elements (formal elements), such as scale, shape, size, composition, and color, whose relationships become the form and structure of a work.

One way of looking at the form/content relationship is to visualize a line with form at one end and content at the other, and to imagine any given work of art as being located somewhere along that continuum. In some works, we immediately see form, and content follows. A monochromatic red painting or a large organic mass of clay will be read first as color or mass. In other works, where the message practically shouts, we are conscious of the formal elements only later, as in a Renaissance crucifixion painting or a sculpture that depicts a group of dead soldiers.

Located between these are works in which form and materials are *foregrounded*, sometimes to support and sometimes to undermine a narrative message.

What you see is not always what you get though. If a red monochrome painting is titled *Untitled Painting #3* or *Red Rectangle*, you will likely see the painting as a formalist, self-referential work that we could place on the *form* end of our form/content pole. But what if you were to learn that the red monochrome painting is titled *After the Massacre*? How would that affect your experience of it? Would the red suddenly become a symbol of blood? If you were then to learn that the red paint was really the blood of the artist, would you again see the picture differently? This is all part of the slippage that occurs between form and content.

Imagine a grouping of stones on a gallery floor arranged in a circle. They have been neither carved nor cut, simply arranged on the floor. Now also imagine a stone carved to look exactly like a boy holding a stone in his hand, which he is about to throw. The stones arranged in a circle, although embodying an abstract geometric form, still maintain their identity as stones. Indeed, their *stoneness* is an important component of the image. In the case of the carved statue, stone is a raw material, which has been *transformed* into something other than itself. Here, physical form serves a narrative content. And even where the stone material is transformed into the stone, held by the boy, it reads as a *representation* of stone, rather than a *real* stone found by the side of the road.

In critique, we will likely talk about the accuracy of the proportions of the stone figure, how it looks from various vantage points, and the artist's technical mastery over the material. In other words, we will evaluate the carved figure as *mimetic*[1] image, and make judgments based on how well the formal elements imitate life and thus how successfully the artist transformed the materials into a likeness, which functions as a *narrative*. The narrative is the story we imagine around a boy about to throw a stone. Depending on formal choices made by the artist, we might imagine an angry protestor or a child skipping rocks by a creek.

But when we come to the arranged stones, we will discuss their positioning in relation to each other and to the space, what kind they are, what size, the shine of their surfaces, and their relation to gravity. Any discussion of narrative meaning becomes secondary, that is, an exercise

in decoding the formal elements in a search for meaning. And even if the way they are formally presented *suggests* a primitive ritual or *evokes* a memorial, they also might be read as formal, that is, empty of any narrative meaning, such that the experience of them is largely derived from the relations of the forms to one another and to the space they occupy.

In both cases, we are assessing the works formally, but the questions change in relation to whether the materials keep their identity or are transformed into narrative image. Thus, when we talk about form, we are talking both about what is materially in front of us, and also ideals of structure and design that exist outside of the work.

In the case of the carved figure, the *ideal* is the human form as well as a complex system for creating a likeness that also conforms to an array of abstract ideas about things such as symmetry, balance, proportion, weight, and so on. In the case of the circle of stones, it is perfect geometry, the essence and identity of the material, and their formal operations in space.

Content, in a sense, is that which is expressed or made manifest through form, or even as form. At the extreme end of this—especially within the traditions of abstraction—form actually *is* content and vice versa. An untitled black square painting, for instance, can be seen as a complete conflation of form and content. What it *depicts* and what it *is* are indistinguishable.

Overemphasizing formal concerns in the critique of a work that has a compelling message may seem absurd, as does looking for complex narratives in a black square. These are the far ends of the pole. But for now let us take a risk and exclusively consider formal matters on their own terms!

Defining Form

For convenience sake, we'll define form as *the means by which one gives substance to an idea.* Form operates in ways that are as numerous as there are formats for work. It's easy to see form in sculpture, which has obvious weight, density, mass, proportion, and three-dimensional shape. In paintings, form is there in composition, texture, palette, and line quality. But formal matters are also in operation in the length of a performance or video project, in the way a site responsive installation is positioned in a specific place, or even in the volume of a sound work. Adding to the complexity of the discussion is the porousness of strict definitions when it comes to classifying work by media,

and the tendency for most contemporary studio practices to cross over into other disciplines.

A three-dimensional form might feature a two-dimensional pattern on its surface. A canvas might become a photograph by the use of liquid light or be a construction that comes off the wall. A complex installation might be constructed with elements that combine sound, video, built structures, and silk-screened panels. Critiquing this endless array of formal and material possibilities can be overwhelming, to say the least.

Formal Praise and Complaints in Critique

So what *do* we mean when we say that we want to consider a work formally and how does this operate in critique? A critique that begins with praise and complaints about formal successes or shortcomings that support or undermine a work might sound something like this: "The story that you present in this scene is interesting, but your figures are badly drawn." "I am interested in the subject of your photographs, but I am bothered by the poor print quality, and the scale of the prints is all wrong." "Your installation of letters from war refugees conveys compassion and you present them without any hint of a patronizing attitude or voyeurism, but I believe that you could have been more inventive with the way the images are displayed."

Yet again, the complaint might be that a well-executed drawing or a perfectly modeled sculpture feels so academic that it does not move us. First responses might be something to like, "It is very well drawn but it leaves me cold. Do you even know what this is about or why you drew it in the first place?" This might lead to a discussion of possible visual devices that could be used, even at the sacrifice of accuracy, for the sake of composition or expressive content of some kind. Can formal choices make a work compelling enough that interest in the content will necessarily follow? Or so compelling that empty content isn't an issue?

What if a work's form and content can't be distinguished, as when formal choices are strictly guided by the inherent qualities of an artist's materials, or when qualities such as shape, color, and spatial relations operate with such primacy that these actually become the content of that work? In other words, the work of art becomes *nonreferential* or truly *self-referential*.

This leads us to consider the terms *formalism* and *modernism*, whose ideas and traditions still inform much of what goes on both in art

studios and in critique rooms. It's worth looking then at what is meant by formalism and some of the ideas surrounding it.

Formalism

Even though all works of art have formal qualities and clearly are *forms* of some kind, not all works are thought to be formalist. Formalist works tend to be intentionally limited to, or highly focused on, their formal elements, such as, shape, color, and materiality. The term *formalism*, which shares the same etymological root as *form*, is an approach to art and art making that emphasizes these elements, often seeing the work of art as a self-referential object as opposed to a vessel for a message of some kind.

Formalism has been criticized, by artists and critics alike, because of its penchant for being self-referential. The disdainful remark, "This work is just formalist," coming from a figurative painter, is an accusation that the work is lacking in narrative substance. As one original member of the New York Ten[2] put it, speaking about Rothko in the old days, "We all thought he was just doing tasteful paintings about nothing!" Whatever your view, it is still useful to examine a work by looking carefully at its formal elements, whether they are pointing to a narrative content or simply pointing to themselves.

To think about how all works have formal qualities, consider how the gesture of a brush stroke can suggest struggle in a painting, whether the image is an expressionistic abstract composition or a bound figure; how the delicate transparent layering of a brush mark–free paint handling might allow for a seamlessness of surface, whether that surface is a milky white color field with gradual tonal shifts or a window into a realist painter's imaginary world; how a filmmaker might assault our complacency with a fast-paced montage and jarring soundtrack, or seduce us with muted palettes and soft fades.

Whether you are looking at a painting of a dog by a pond or an abstract field of color, from this perspective, it is the formal qualities of the work that produce an aesthetic experience for the viewer. Thus, *formal matters* matter.

Formalism and Modernism

If we accept the formalist proposition that the aesthetic value of a work of art lies in its formal qualities, then any given medium is best judged by its *trueness* to the formal qualities inherent to it. That means that a work

produced in a given medium might evolve toward a more and more rarified articulation of its formal particulars. And a work of art could even ultimately *be* just about its formal qualities. Following this logic, works of art become disconnected from representation and increasingly abstracted to the point of becoming entirely self-referential. In other words, a work of art no longer *represents* something out in the world but *presents* itself. The most successful works are those that are made according to the natural inclinations of the medium out of which they are constructed. But can a work ever be just about its formal qualities? How might this work?

Formalism and Modernism go hand in hand. Modernist thinking about art is predicated on the assumption that art history is a progressive movement toward greater purity in each medium. A painting is judged not by what is happening in an imagined space beneath the surface but as a *thing,* essentially flat and made of physical paint. A sculpture is about space, volume, balance, modeling, materiality, and possibly color. The idea is that the raw material that the artist uses has inclinations of its own, an essence, if you will. It is what it is. The transformation by the artist of the material into something other than itself becomes a transformation from something honest to something dishonest. The rock no longer looks like a rock. The artist's craft was so good that now when I look at it I see a boy. The *rockness* of it has been subjugated for the sake of a narrative image. The viewer has been deceived.

One critic associated with this strain of thinking is Clement Greenberg.[3] For Greenberg, competence in each art discipline coincides with the unique nature of its medium. Standards of quality are found through purity of the form, and purity occurs through self-definition. What had been for the Old Masters limitations to be overcome—the flat surface, the shape of the support, the natural properties of pigments—became to Modernist painters the essential qualities of the medium to be embraced.

Abstraction and Association

The British sculptor Anthony Caro once referred to a time during which it was very difficult to create a sculpture that did not remind one of something else.[4] Caro's investigation into the language of abstract sculpture was a function of the specific period in history in which he was working. With this comment, the artist was revealing a problem, as he saw it, not just with *representation* but also with *association.*

The very idea of a sculpture (or painting) that resists "reminding one of something else" is the essence of the self-referential work, a work that can only be assessed formally, and where the content *is* its shape, color, material, weight, and arrangement of its parts in composition.

Abstracting and Abstraction

In critique, the terms *abstract* and *abstraction* are often thrown around and applied to a range of works from distorted drawings of the figure to sculptures formed from steel triangles. The term *abstraction*, often replaced by terms such as *nonrepresentational* or *nonobjective*, is used to describe forms that don't resemble the *real* world. But its root, the Latin verb *abstrahere*, from which *abstraction* is derived, literally means to pull or draw away. Thus, *abstraction*, in the purest sense, begins with *reality* and *draws away* from it, revealing the underlying lines and geometric shapes, transforming a figure or potted plant into something hardly recognizable. What is important to remember is that you can think about *abstract* as a verb (something that you do) that leads all the way to pure abstraction. In the same way that we used a line to visualize form and content, think of representation and abstraction as located on far ends of a line. If you start on one end of the line, with an image that looks just the way a camera sees it and then begin to abstract it into lines and shapes, you will be moving toward the other end of the line. At some point, when the image is completely unrecognizable, you will have reached *pure abstraction*. Much art lies somewhere along the line, maintaining a recognizable reference to the *real* world but also revealing a geometric understructure or foregrounding the materials of which it is made.

Critics and art historians have argued as to whether the term *abstraction* should be used to describe works that don't refer to anything. The argument for the critics is whether the pure abstraction is still in some way making reference to some original figure or potted plant, thus their preference for terms such as *nonobjective* or *nonrepresentational*. This is a fair criticism, as many artists, especially ones who have seen themselves as formalists, think of their art objects as completely self-referential. Nevertheless, many contemporary works that appear to be formalist claim to *represent* something in the *real* world. Graphic paintings that appear to be geometric abstraction might actually be referencing corporate logos. A series of flat color fields, rendered in skin tones, might actually be portraits of the artist's friends.

Realism versus Abstraction: A Real Issue?

In critique there is often much discussion about realism. Does the drawing "look" like the still life? Did the student manage to model the light in a way that clearly articulates the model's torso? Is the figure modeled accurately in clay or proportionally rendered in cast fiberglass? Does the wood or Styrofoam carving present an accurate representation of the object? Often, achievement is measured by a student's ability to make a drawing or painting that approaches the accuracy of a photograph. In sculpture, a figure that can be read as a real person in a room gets an enthusiastic response. Many students equate craft with the ability to imitate nature.

The esteem associated with accurate rendering comes down to us through the history of painting and sculpture, traditions that began in a prephotographic age. In both disciplines, accurately rendered human figures often operated as characters in narratives. To function as effective narrative, sculpted and painted images had to convincingly look and feel like real people, much the way a character in a Tolstoy novel is crafted with detailed physical attributes and a complicated psyche. The three-dimensional figure, like its two-dimensional counterpart in a painting, operated in a pictorial manner like an actor in a scene. Realism was able to convey a readable story. It was not about the marble or the bronze but, rather, the creation of characters and narrative, much the way a novelist does.

What Is Realism?

It is worth considering how we define realism. Is it what we can see with the naked eye? Through the lens of a camera? Can what we see through a microscope or a telescope be considered realism? Vision as we know it is an interaction between a limited portion of the electromagnetic spectrum and our own perceptual apparatus. Does the fact that we can't *see* most of the electromagnetic spectrum make those portions of the spectrum any less *real*? Are the seemingly abstract shapes of the blobs under the microscope less real than a potted plant on a nearby table? Questions like these have been changing how artists have viewed "reality" since the early twentieth century. They have prompted some artists whose images may appear to be abstract and not easily read to still think of themselves as realists.

It is also interesting to consider how many contemporary realist painters work not from life but from photographs or even projections.

Rather than observing *real* people and objects, where the eye and brain become translators from three-dimensional space onto flat space, new realists often work from flat to flat. How important is the source? If David Hockney's recent theories, which argue that some of our most revered master painters used mirrors and lenses, are true, does that alter how we think about craft? Many portrait artists work from multiple photographs. Many painting students are more comfortable using photographs as a source than they are working from life. And yet, if you offer them an opaque projector, they feel that would be cheating.

Self-portrait assignments are the staple of traditional figure and life classes. But self-portraits must either be done from a mirror or a photograph. Both of these methods require the artist to transfer a flat image on a flat surface onto another flat surface. What makes realism realistic in all of this? What gives it the mystical aura of the magician's craft? Where does the craft reside? And how relevant is process to the integrity of a finished work? What about sophisticated mold-making techniques used to replicate a three-dimensional form, or computer software and prototype equipment that can scan an object and carve a replica in a variety of materials? How do these differ from works modeled through eye and hand?

The sculptor Constantine Brancusi once said, "When you see a fish, you do not think of its scales, do you? You think of its speed, its floating, flashing body seen through water. . . . If I made fins and eyes and scales, I would arrest its movement and hold you by a pattern, or a shape of reality. I want just the flash of its spirit."[5] Rather than seeing the work as abstract because it does not resemble the way a fish *looks* to the human eye, Brancusi's realism resides in the way the fish *is*—alive and in motion. One can think of artists like Brancusi as expressing the object as a verb rather than a noun, that is, the swimming of a fish or the growing of a flower, rather than the traditional *dead nature* that the French term for still life suggests.

Nevertheless, drawing from life, whether it be human figure or potted plant, remains a mainstay in most college art foundations curricula. Figure modeling, though not the staple it once was in art schools and college art departments, has in recent years enjoyed a resurgence, in part because of the figure's seemingly inexhaustible narrative potential. We still have bodies and are surrounded by material objects. In the context of a basic skill-building class, the student's work in critique is usually judged by the accuracy of the reproduced figure to the real-life

model. A class with the shared goal of gaining technical proficiency in representing the figure will likely conduct a formal critique centered on how well a student has reproduced the model's complex form.

The challenge in critique in a more advanced course with a wide range of artistic practices is to determine whether this standard of verisimilitude or another standard is appropriate to the work. In other words, in looking at the work formally, we ask how critical is it to the success of the piece that these forms imitate reality, and if so how?

The Persistence of Association

There is an old joke about a psychiatrist who gives his patient a Rorschach test. As the therapist presents card after card of ink blot abstract shapes, the patient insists over and over again that what he sees are images with explicit sexual content. When the doctor reports that this indicates a dangerous obsession, the patient replies, "But doctor, *you* are the one with all those dirty pictures!"

For many students, there is still a tendency to approach nonrepresentational work by first trying to create associations. What does this shape remind me of? That abstract shape looks like a duck or is it a fist? I see a head. The possibilities are limited only by the number of participants willing to play the Rorschach game.

Perhaps this comes from the long history of art at the service of the *mimetic* (or imitative) function. Or maybe it says much about the power of even the most reductive forms to evoke emotional reactions and about the mysterious ways in which our brains function, how we humans are symbol-making creatures compelled to make meaning.

The danger in making such free associations in critique is that they can lead to so many subjective opinions, and so many irreconcilable and divergent paths, that it becomes impossible to sustain a critical dialogue. The association game in critique is like the childhood experience of discovering rabbits and dragons in cloud formations. It reminds me of this. It reminds me of that. Although useful, even imperative, to a complete examination of the experience of a work, if taken too far, subjective associations can dissolve into a full breakdown of discipline.

That said, associations occur and need to be recognized in critique. When looking at work with a formal eye, the shape of a form or the uprightness of a figure may embody a likeness, which becomes the "content" of a work. Here, form slips into content. A shape or form that

doesn't really look like anything but that reminds us of other things adds those identities to it. This slippage of identity can be called the *poetics of meaning.*

Thus, association is not necessarily a thing to be avoided either in making art or looking at art. Indeed, a play with the possibility of complex associations in abstract forms or shapes can be a substantive part of many artistic practices.

LOOKING AT A PAINTING FORMALLY

What Makes a Painting a Painting?

What makes a painting a painting? Faced with the diversity of practices within the discourse of contemporary painting, is there a common language for discussing the many forms painting takes? Are there specific ingredients that a painting has to contain in order to *be* a painting? Does it have to hang on the wall? Contain pigment of some kind? Be on canvas or board? Have a picture plane? Be rectangular? Be made with brushes? As you read this, you are probably thinking of many well-known paintings that aren't made this way, that specifically lack at least one of these elements. Are there particular elements that a painting *must* contain to hold onto its identity as painting? Can we talk about an academic figure painting in the same way that we discuss a suitcase sprayed with krylon enamel? Or a raw canvas pinned to the wall in the way we talk about a color field painting? What about several piles of brightly colored dry pigment on the floor? Or dried latex applied and then removed from a canvas support and then laid out on the floor? Or a video image projected onto a framed canvas?

Are disciplines converging in such a way that painting is at risk of continual slippage into sculpture, or into photography, or into the digital arts, video, or performance? Does painting still even have an identity of its own?

Painting as Its Own Context

Ever since painters left the architectural frames of cathedrals and chapels to make transportable oil paintings on stretched canvases or wooden panels, they have tended to accept the four sides of a canvas as natural borders that frame a discrete pictorial space. The real world beyond that space is accepted as extraneous. Thus, the white canvas is

a built-in context for a painting, in that it houses, frames, and forms a dialogue with what it contains. In this sense, the white picture plane is to the painter what the gallery space around a sculpture is to the sculptor. Many painters—representational and abstract alike—have accepted the stretched canvas surface or primed board as a neutral ground on which to hang a painting. This view is based on an underlying assumption that a painting occurs on the surface of the canvas or board. The stretcher and the sides of the support are functional necessities and remain, for all practical purposes, invisible.

While we are ignoring the physical aspect of a painting, we might also ask if there can be such a thing as a neutral or ideal picture plan that isn't associated with anything outside of itself. What shape would it be? A rectangle placed horizontally suggests a landscape. Placed vertically, it suggests a portrait. Even so, artists have consistently accepted the rectangular format as relatively neutral, conceding that any implicit meanings have been all but extricated by the pervasiveness of such paintings within the tradition.

A Painting's Internal Logic

Beyond its relation to things outside of itself, such as its place in art history, where and how it is presented, or even the other works of art around it, we can speak of a painting as having an internal logic. When this frames our discussion we can begin our formal assessment by first asking a series of basic questions. How big is the work? What shape is it? How far from the wall is the surface? Are the edges painted or framed? Have the edges been ignored? Are the staples visible? Is it a stretched canvas? A board or panel? Something else? Is the raw surface beneath the painted surface visible? Is it treated with white gesso or a transparent sizing? Has the surface been altered in some way? Cut into? Sewn onto? Is the surface made out of paint? Or is it some other nontraditional painting material such as tar, beetroot, or shampoo? Is the paint thin, uniform, or thick? Is it smooth or textured? Are the brush strokes visible or hidden? Do the brush strokes present physical evidence of the artist's gestures? What kind of gestures are they? Is there color? What kinds of colors? Are the values close or are there large contrasts of value? Is the painting high key or low key? What kinds of marks can be seen on the surface? Are they about line? What kinds of lines? Are they thick or thin or varied? Are they about gesture? Do they have a physical presence? Did the artist use brushes? What size brush? Were a variety of

brushes used? Other tools? Are there other elements? Collage? Found objects? These questions all address actions going on *within the frame*.

Edges

The first edge is the physical outer edge of a painting. This edge separates the work from the rest of the world, marking off the world within the pictorial space. It establishes agreed-on borders that mark off the painting as a kind of autonomous territory. The next frame is made out of the relation of the image or worked area to the physical outer edge. Consider these edges within the frame. Are they negotiable? Was the painting executed on canvas stapled to a wall, and then glued onto a larger surface? What if the artist painted all the way to the edges of a raw canvas, causing the outer part of the image to be wrapped around the edge, when the work is finally stretched? If the edges are painted over, in this case, the image becomes cropped. If the image is left to wrap around the edge, what happens? Now the pictorial space has been expanded into three-dimensional space. What if a drawing was begun on a huge expanse of paper so that it could expand as needed? In all of these cases, the artist has made compositional decisions based on a pictorial space that no longer exists. One way around this is to begin a drawing or painting by first marking off the edges of a pictorial space and work within that. At the same time, expanding and contracting the pictorial space can be solutions to compositional impasses and create surprising results.

Edges also separate discrete areas of color or shape within a painting. They are the transition from one space to another within the picture plane. Are the edges in the work in front of us so clean that they seem factory made? Are they blurry to the extent that you can't tell where one area begins and the next ends? Do they look like they were taped or scumbled, carefully painted or accidental? How the artists dealt with the interior edges is all part of the reading of a painting.

Line

Line is the most basic mark—a stick pulled through sand, a burnt ember scrawled across the wall of a cave, the tracks of a snail, or fine filaments of a spider's web. Line is considered by many artists to embody the direct channel between the brain and the hand, a means itself of thought. And line *is* content depending on what it is made of, the gesture that created it, and where it resides. A fast-moving, highly pressured line

feels angry or aggressive. A thin wobbly line has a tentative message. Think of a large scrawled confident signature as opposed to a small hesitant one. What does it tell you about the signatory? Line can be ordered or chaotic, fast or slow, thick or thin. It can be the product of an emotional outburst or a machine. It can make itself almost invisible at the service of illusion or flaunt its identity as a mark on the page. Line also occupies and divides space and, thus, influences how one reads everything around it.

Color

Color is to painting what line is to drawing. Color carries with it emotional content, and the perception of it changes depending on the other colors nearby. Indeed, color is an effect rather than a real property. Thus, the perception of a color depends largely on what colors are around it. While students learn the nuts and bolts of color theory in foundations courses, suffice to say that an analysis of color is integral to any formal critique of a painting.

Is the painting high key or low key? Is the palette limited or are there many, seemingly unrelated colors? If it is limited, how so? Were only earth colors used? Saturated colors? A combination of the two? Is there an obvious logic to the color, such as the use of complements or triads? Does the painting have a temperature—hot reds and oranges or cool blues and greens? Is the painting limited to analogous colors? Is it a monochrome? How are the colors distributed across the picture plane? Is it a harmonic distribution; that is, has the artist considered color extension in relation to saturation within triadic or complementary relationships? Or is it unbalanced, thus creating an evocative or emotional space? All of these are formal elements and have a bearing on how we perceive a painting.

Composition

Composition is generally thought of as the arrangement of lines and shapes within a pictorial space. As with color, there are books on the rules and regulations of harmonious composition that have come down to us from the masters. These are usually covered in foundations courses and quickly forgotten. To many students, thinking about composition in terms of triangles and the golden rule feels like being forced to learn a dead language that no one speaks anymore. Nevertheless, many compositional traditions are based on shared human perceptions. For instance, a composition that forms an equilateral triangle centered in the

picture plane feels stable as opposed to one formed from an isosceles triangle, whose longest side runs diagonally from the top right corner of the canvas to the bottom left. The one is static, the other dynamic. A circle in the center of a picture plane, as in the Japanese flag, feels balanced while one at the bottom edge feels pulled down by gravity. A large shape dominates a smaller one. As the number of marks or shapes on a picture plane increases, each one loses significance, much the way a child who is one of twelve has a smaller presence in a family compared to an only child. Or the general on a battlefield stands out against a mass of uniformed soldiers. In critique, we analyze how the arrangement of shapes, lines, and forms works on us. And how this affects other formal elements and is affected by them. We can talk about composition in purely formal terms and also in relation to how it affects the way we make meaning out of the painting, which we will take up again in the next chapter.

Fields

Fields in painting are like fields in landscapes. Imagine a field of green grass, a field of purple flowers evenly distributed in a green field of grass, a field of red, yellow, and white flowers scattered over a blanket of snow, or a scattering of white flowers coming up through snow. Imagine the night sky on a dark night away from city lights, or the flecks of light on a piece of ocean. These are all fields. Fields are composed as all over patterns across the picture plane. The composition operates not as juxtaposition, as in a painting of a scene or a figure, but as layering. Imagine a graph with an x and y axes. Fields can lay on the plane of the x,y axes, or can be layered, one over another, on the z axis. In painting, fields might be made of flung paint, carefully repeated motifs, buttons sewn to a canvas in a grid, a tangle of lines or brush strokes, or a single color. Fields spread out to the edges of the canvas so that the pictorial space becomes a fragment of an imaginary larger field that exists beyond its edges.

Painting as Crossroad of Image and Object

Whereas a painting occurs on the surface of a support, it also becomes a part of that support. Thus, apart from its physical surface and the image that occupies its surface, the painting is also an object. As an object it occupies space in relation to the other objects around it. It stands away from the wall to a greater or lesser extent. It has weight and volume. Formal choices that the painter makes can highlight or obscure a painting's *objectness*.

If the painting's edges are thick, causing it to stand away from the wall, its *objectness* is emphasized. The eye moves from the frontal surface to the edges. The surface becomes part of a larger organized whole. The artist is now obligated to think about what the edges mean in relation to the surface of the canvas. Are they an extension of it? Does the image wrap around the stretcher? Should the edges be painted as a continuation of the surface? Do the edges form another related set of surfaces? And if the edges of the canvas are of a standard depth, is the artist obliged to deal with them? Some painters accept the stretched canvas as a neutral ground for painting, which they see as occurring exclusively on the surface. Are they no longer obliged to deal with the edges?

What does it mean if the edges of the canvas become holders of the spillover from the painting process? Or they are covered with staples, which hold the canvas to the stretcher bar? A painting, with untouched edges and of a standard depth, gives the message that painter and viewer agree that the "world" is the surface of the painting. It is its own context. Does this become an active statement by the artist that the painting occurs exclusively on the surface? That she views the stretcher as a neutral place to hang a painting? That she is not interested in the painting as object? The moment a painter calls attention to the support, and the painting reverts to being an object in space, the viewer looks not just *at* the surface or window but *around* it. The foregrounding of the painting as object, changes the reading of the surface, which is now in dialogue with its own constructedness and identity as an object.

A canvas can also be seen as a plane or membrane. The canvas can have objects attached to it or be punctured with cuts. These actions call attention to the painting's identity as object and undermine a seamless reading of its surface. When a painting begins to foreground its identity as object rather than surface, it starts to interact with the space that it occupies. It becomes an object in space.

Shaped monochromes appear to be floating in the typically vast, white wall space that contains them. In this case, the paintings themselves have become figures on a larger ground, that of the gallery wall. They operate primarily in relation to the wall space that contains them and secondarily as discrete painted surfaces. A group of shaped monochrome paintings by the artist Ellsworth Kelly, for instance, seem almost to become a composition of colored shapes on the picture plane of the gallery wall.

Shaped canvas constructions, while still pointing primarily to themselves, also address the space they occupy by projecting in and out, not only on the x,y axis of the wall, but also on the z axis, which runs perpendicular to the plane of the wall from any given point on the painting's surface.

Scale

Scale weighs in, too. A large canvas tips inherently away from *object* toward pure surface because the depth of its edges is much smaller. The edges of a large painting are slight compared to its surface area. It's hard to imagine holding it. It approaches the domain of architecture. Nevertheless, if we increase a painting's depth or let the painted surface extend over the edges, the work can shift toward object. The edges become foregrounded and cease to be neutral. Shape changes the dynamic as well. Once a painting shifts away from the space of the rectangle (painting's most neutral territory), it moves further toward the province of the object.

Scale refers both to a work's size in relation to the world around it and to the relation of its parts to one another within the internal logic of the whole. It also encompasses the relation of those parts to the whole. The first could be called a work's absolute scale. The second, its relative scale. Large works seem powerful, authoritative, ambitious, and have a seductive potency by their magnitude alone. It is much like the difference between seeing a movie on the big screen, where the close-up shot of an actor's head is eight feet tall, compared to seeing the same shot on a small video screen. The one is larger than life—a vast landscape—the other is pocket-sized. Note also as well how much less material movie screens are compared to the televisions, which are themselves objects. Relative scale can be thought of as the same kind of difference but operating instead within the picture plane itself. Imagine a scene of a small child, perhaps made to seem even smaller by a bird's-eye camera angle. Onto the screen comes a towering bad guy. The relative scale of the two supports the narrative message that this child is weak and vulnerable in the face of a much greater power.

Absolute Scale

In painting, a large work carries with it associations with history, the works of that scale that came before it. It seems museum size. Heroic. It already seems important. If it is larger than the viewer, it feels more

like an environment or a wall than a picture. One has to step away from it in order to see it. A small work has an intimacy about it. One must be close to it to see it. It seems to belong in a furnished room in an intimate setting. It is an object that can easily be held. It's the size of a lamp, or a book, or small mirror. A small painting is naturally a window into an illusion. One feels the frame, even in the case of an unframed work.

Relative Scale

How does the *relative scale* of marks or images on a picture plane impact what we see?

Airplanes

A student brings to critique three paintings. All show white paper airplanes on large blue grounds. In the first painting, the small white image of a paper airplane seems to be floating somewhere near the center of a cerulean blue ground. The blue paint, which covers the canvas immediately suggests a sky, both by its color and by its relative emptiness. The image of the paper airplane supports this reading because, as a narrative, it appears to be flying or floating, for it is unattached to anything. We look at the scale relation between the airplane and the blue ground and because the blue ground is large in relation to the image of the white airplane, the painting has a light, airy feeling. The airplane appears small in relation to the vast sky and yet significant because it is the only figure in the painting. What happens if the airplane covers over half of the picture plane? Does it seem heavier and less airborne, with less expanse around it? Does it suddenly feel like a close-up of a small airplane? Or does the airplane (figure) now dominate and overwhelm the sky (ground)? What if the airplane is in the center of the pictorial space? Off to one side? What if part of it is cropped, almost fastened to the edge of the painting?

The second painting in the group has two airplanes, a large one at the bottom of the picture plane and a much smaller one near the top. Does the sky feel more three-dimensional because our eyes see something that is lower and larger as being closer to us, whereas the smaller one in the upper portion of the picture plane gives the impression of receding in the distance? In this case, the placement of the airplanes and their relative scale both act as visual cues for deep space. This is because objects are diminished by distance, and their placement in the lower area of the picture plane suggests proximity. But what happens if the relative scale between the airplanes is inverted so that the small airplane is at the bottom? Do the two opposing visual cues cancel one another out? Does it make a difference if

the sky is painted in a completely flat blue rather than one modeled out of warm and cool hues that would create a push-and-pull effect that reads as deep space? How does this painting change if both planes are so small that they read like dashes of light? Or if they both spread out beyond the confines of the canvas and, cropped at the edges, leave only small areas of negative blue space?

The third painting in the group appears to be covered with gestural brush strokes of white paint, evenly distributed across the blue ground to create a field of white marks. The blue ground beneath appears between the brush strokes so that they seem to be floating in the air, much like snow flakes or falling flower petals. The white marks still operate as a field of figures floating on the blue ground. What happens if the marks become so dense that their edges touch at several points and many overlap? Now both the white of the marks and the blue of the ground begin to form a blue and white pattern of connected shapes. It is now impossible to tell which is figure and which is ground. They are conflated into a single, relatively uniform pattern on the surface of the canvas.

As you can see, each formal decision creates meaning for the viewer. Any given painting is a complex web of such decisions. In critique, we try to break down what we see and examine how it works on us.

Format

Format refers to the shape and proportions of a pictorial surface. As discussed earlier, most paintings are rectangular in format. But many are not. Thus, if we are looking at a rectangular painting, we already know one of the following: either the artist is accepting the rectangular format as a kind of neutral ground on which to paint (and this is precisely the right shape for what the artist has in mind), or he hasn't really thought about it. On the other hand if we are presented with an odd-shaped canvas, or even a rectangle with extreme proportions, we know right off that the artist is considering the relation of the picture to the picture plane. For instance, an artist might choose an extremely long horizontal support on which to paint a landscape, thus emphasizing the horizon line and a sense of panoramic expanse and tranquility. A nonrectangular support immediately contextualizes a work among the many other works that have challenged the horizontal picture plane. A nontraditionally shaped support becomes a primary carrier of content that immediately asserts the painting's identity as *object* over its identity as *painted surface*.

Mimesis and Improvisation

In Book IV of the *Poetics,*[6] a fifth-century B.C. handbook of sorts for playwrights, Aristotle talks about two natural instincts that motivate the writing of poetry. He argues that poetry sprang from two causes, each of them lying deep within human nature. The first was a natural instinct for imitation (mimesis) and the second, an instinct for harmony and rhythm, which through a kind of rude process of improvisation gave birth to poetry. One might easily place the lineage of painting that comes down from the Renaissance in Aristotle's construct as operating from the first instinct, motivated wholly by the desire to imitate nature. The modernist painter, however, came to painting largely from the second instinct, as a kind of improviser. The part of poetry, which is rhyme and rhythm, meter and movement, is much like those formal connections, which orchestrate the whole of a canvas, outside of any referential meanings. Where painting has relinquished its instinct for imitation, this second instinct has seemed to motivate and become the full content and experience of the work.

Many figurative paintings operate in both arenas of activity. Although concerned with getting the figure right, the figurative painter may well improvise within the totality of forms, often sacrificing accuracy for expressive distortion or pictorial integrity. To many modernist and contemporary figurative painters, process can't be detached from the final image.

Surface, Gesture, and Process

Early modernist painters abandoned the traditional idea that a painting had to be a seamless retinal image in favor of exploration of a painting's flat surface, turning a painting itself into a kind of record of its own creation. Painterly surface, as a result, could be seen as a record of an act and the door was open for relocating the place of aesthetic meaning from the image itself to the activated surface, and ultimately to the *moment* of the aesthetic act. We see this as early as Cezanne's layered patches of color and Van Gogh's directional brush strokes, where the gestures of the artist's hand have been tied to the implied gestures of a depicted natural landscape or object, as perceived by the artist.

We see this in American abstract expressionist painting where the act of painting is foregrounded to the extent that a painting's success or failure rested curiously on its ability to convince the critic that the

moment of its creation was an authentic one. In this way, the artist becomes integral to the equation, no longer separated from the art object. As a result, the artist's *craft* is as concerned with the development and assertion of *the self* as it is about the skill of mixing color or modeling light and shadow.

When *process* drives a painter, the painting takes on a voice of its own as it becomes formed, and even begins to have a say in the choices that culminate in its final form. In other words, the painter discovers what the painting is or will look like as she goes. *Process* is often self-driven by formal and material choices as they are made. The painter, tuned into an emerging structure of relationships, guides and is guided toward an elusive end. Thus, the painting is, in a sense, *discovered* through the act of painting. The skill or technique for making such a painting then becomes more about a frame of mind, an ability to see and respond, than about techniques for rendering accurate proportions or mixing color. In formal critique, we look at the painting as evidence of this process.

Hesitation

A student put up for critique a large abstract oil painting, which contained vast areas of color and some calligraphic black lines that seemed to loosely structure the picture plane. The instructor, who was a die-hard abstract-expressionist of the California school, stared for several minutes at the canvas. Finally, pointing to a small area in the lower right quadrant of the picture plane, he barked, "I can see you hesitated there." The student blushed and admitted that he had really worked that area and still wasn't satisfied with it.

Here the instructor, by looking carefully at the surface, was able to recreate the act of painting to such a degree that he could spot the area where the act had broken down.

Surface as Evidence of an Act

Indeed, paintings can be read. Their surfaces contain all the secrets of their making. A student can look at a painting in a gallery or museum and *read* exactly how the painting was done. She can detect the kind of ground that the artist put down, whether the work began as a cartoon on a middletone ground with transparent layers of color slowly added, culminating in piled-up opaque earth colors and then whites (as in a Van Dyck or Rubens) or whether it was painted directly without medium

in one sitting (as is the case in much turn-of-the-century French paint-ing). Students of painting should spend a lot of time in front of real paintings for the same reason that students of writing should read a lot of good books!

The surface of a painting is where it all happens. The surface differentiates a painting from other things. Whereas the image is transmittable, the surface isn't. It is singular. You have to go to it. The surface is a kind of document of the activity that created the painting. The painter controls how much of the act is left visible and how much is covered up. Visible brush strokes are signifiers of the *act* of paint-ing. A canvas covered with gestural brush strokes evokes in us the image of an artist directly expressing something onto the canvas. Often it reads as spontaneous emotion or movement. If visible brush strokes foreground the *act* of painting in the mind of the viewer, they also invoke the artist at a "spontaneous moment of genius."

Thus, a critique of a painting of this kind might almost sound like the assessment of a performance. "You hesitated at this point," "These strokes seem tentative, those bold," "These layers seem thin, here you stopped too soon!" This approach may not get to purely formal con-cerns, such as the relative scale of shapes or the variation of red used. But it may get to the larger question, indeed, the very thing that makes the painting tick.

Speaking about Jackson Pollock's painting, *Autumn Rhythm*, Kirk Varnedoe[7] described Pollock as procrastinating in front of a large white canvas for days, and then painting the entire painting in one seventeen-or eighteen-hour session. "He got onto something and let it rip." Varnedoe points out the family of marks, hooks, and commas—that become the consistent vocabulary throughout the work, as evidence of a single, prolonged creative gesture.

Painting as Representation

A painting is an object; it is a surface with paint, which is also a record of the process of its creation. But an artist might want to play down that aspect of a painting and emphasize that it also can act as a transparent vehicle for narrative content (*representation* or *mimesis*). To assess this we might ask: are brush strokes and perspective systems hidden the way a magician hides the mechanisms that create a magical illusion? Is image paramount, and materials and technique, practically invisible, existing only to serve the illusion? With a representational painting in

the purist sense, the image is a convincing narrative, standing in for the *real world* and abiding by its visual logic. We would indeed judge this kind of painting by its *likeness* or visual proximity to that which it represents, as evidenced by the deftness and clarity of its perspectival systems, the harmony of its color schemes, and how well the narrative content is carried by the artist's formal choices.

Since representational painting is a natural vehicle for narrative content, our critique may focus on this. Once a narrative intent is established, we might consider how well the formal elements come together to support an intended narrative, much the way a book critic evaluates a mystery writer's plot structure or character development in motivating that plot. Questions might be something like: the girl is accurately rendered, but the angle of her head, reflected back in the mirror, is wrong. Or the table is out of scale with the bed. The skin looks dead; you need to add some cadmium red light to the mixture in the areas around the nose and cheeks. Or, the figure sitting alone on the bed is accurately rendered but I don't feel her isolation and sadness. Perhaps, if you darkened the area around the ceiling, it would create a sense of enclosure, or move the light source from the window to the table lamp to make the scene feel more intimate. (More on these concerns when we explore signification in the next section, *The Story It Tells*.)

But if the object is to hide the process and materials in favor of a seamless illusion, then does our critique also focus on how well the brush strokes and other physical aspects of the surface have been subdued? Can we take this a step further to ask, do materiality and process become irrelevant at some point when image is all important? Can image really be the *only* thing that matters? If so, does the fact that we have a physical painting, as opposed to a photograph or film still, become extraneous? Even if we have no objections to formal choices, which the painting itself presents, we still need to ask whether this is the best form for the work to take.

How critical are material and process to a given work? Is the artist's narrative best served by paint on canvas or might a video projection, liquid light image, a photograph, or even a film be a stronger venue for some ideas? In other words, could one of these other media tell the story more effectively? And if we stick with painting, how important is it that rendering be done from life? Is it cheating if the artist has used a projector or some other device?

Painting as Presentation

How do we talk about a painting that isn't of anything? Clement Greenberg said, "The presence or absence of a recognizable image has no more to do with value in painting or sculpture than the presence or absence of a libretto has to do with value in music."[8] Indeed, pure abstraction presents the operations of pure structure, much the way music does. Rather than representing the perceived world, the painter creates structures that parallel or allude to an unseen understructure or even the structural operations of the brain.

A painting like this might be a single field of color, a group of gestural marks, a repeated motif, or an array of lines and planes of color. The interplay of such structural operations destabilizes traditional dualities such as form/content and figure/ground by blurring the lines between them. Their relative positions become inverted or even conflated. The history of pure abstraction is in many ways the history of the grid. The grid (like a piece of graph paper or a chessboard) refuses narrative by not allowing a perspectival system of any kind.

Greenberg argued for a kind of painting that refuses to be the carrier of a narrative, much the way a symphony is a complex structure whose emotional and expressive content relies purely on the structural relations set up by the composer. Color, line, repeated motifs are orchestrated across the surface of the canvas much the way melody, harmonic textures, and repeated motifs are arranged by the composer.

Narrative or a lack thereof is not a matter of value but simply a matter of difference, much like the differences between a symphony and an opera. Formal elements, such as color, can exist on their own without being at the service of an image. An artist neither has to make a banana yellow, nor does she have to make yellow a banana. Color is color. We can look at the formal structure of a painting on its own terms, not by how well it serves a narrative image.

Painting as Flat Surface

We begin by asking if the painting is operating as a flat surface. Is this a work where the artist has purposely rejected seamless illusion? Rather than *representing* or documenting the world of conventional sight the way a camera might, does the artist explore the relation of image and the pictorial devices that *represent* it? Rather than covering up the devices of painting, are these exposed in the work? Is the illusion of

three-dimensionality undermined, our attention called to the physical surface of the canvas? Does the painting's surface, in a sense, become more like a wall than a window? Painting like this differentiates itself from retinal, transmittable media like photography by calling attention to its own materiality, its presence, singularity, and its unique identity as both image and object. Whether the painting contains recognizable images or not, the illusion of three-dimensional space is still undermined and the flatness of the picture plane and the physicality of the surface still reaffirmed.

How can a painting that strives for seamless illusion and a painting that seeks to undermine illusion be evaluated by the same criteria? One is covering up the devices of painting while the other is pointing to them. Without a relevant framework for discussion, we end up sampling oranges to appraise apples.

A formal critique of a work, which has either moved away from pure representation or transgressed the frame, requires us to move our questions away from image and toward object. Focus will be on the physical surface, as opposed to an image that overpowers it. Nevertheless, many of the formal questions remain the same. In their quest for structural integrity, formal elements, such as color, the arrangement of shapes, brushmarks, scale, and surface application, will be at the service of different things. The overriding question in any critique that focuses on formal matters will be to determine if the formal choices that the artist has made are serving their purpose, whatever that might be.

LOOKING AT SCULPTURE FORMALLY

The Object in Space (Figure and Ground)

A good place to begin a formal assessment of a sculpture in a critique is to look at the work in relation to the space around it and to ask, "Where does the sculpture end and the room begin?" This question might seem more philosophical than practical, but it allows us to conceptualize a sculptural form as a three-dimensional shape defined by "the edge of the object" and to consider the operation of negative space in sculpture. Such a question also forces a consideration of the spatial context of the work, that is, whether and how it operates in relation to the specifics of a particular site. Any discussion of sculpture made during and after the twentieth century requires a critical look at the work in relation to the

space around it, whether the artist has consciously engaged with the issues of site specificity or not.

Many students are accustomed to the terms *figure* and *ground* in painting, where the figure operates in relation to the surrounding two-dimensional space. But the same principles can be applied to sculpture especially when we substitute the white cube for the white canvas. The space not occupied by the object becomes the negative space. This is an important formal consideration, because compositional choices are explored not only within the sculptural object but also through the manner in which the sculptural object behaves within the space.

The Discrete Object in Space

A discrete object, even if constructed out of multiple parts, can be read as a single form. Indeed, all three-dimensional *forms* are essentially made up of an infinite number of *shapes*.

For some sculptural forms a shift in the viewer's position results in a radical change in its shape. For example, a symmetrical form appears roughly the same from any position. But the dynamic sense evoked in some sculptures occurs precisely because one view completely contradicts another. For instance, the silhouette of a basic cylinder seen from one angle becomes a rectangle; viewed from another, it becomes a circle. Imagine a cannon seen from the side and then head-on; a friend in profile or facing you; a figure, cut from thin plywood, seen from the front and then turned.

Relief sculpture operates from a frontal viewpoint. This includes sculptures that rest in boxes or other presentation devices that obstruct back and side views. But free-standing forms can also encourage us to look at them from one side, perhaps by creating the sense of *front stage* and *back stage*. Nevertheless, if the back of such a sculpture is visible but unattended to by the artist, it becomes a problem.

Altar

A student presents a free-standing wooden box approximately seven feet high, four feet wide, and three feet deep. Inside are various wax-cast objects including hands, feet, and a small shoe, as well as red lingerie and pop star posters. The inside of the box has been carefully upholstered in red velvet. The outside of the box has been carelessly painted with a wash of flat black paint. A formal discussion of the work includes observations that

the sculpture has a definite front and back, but several students object to the poorly painted back and a few suggest that the artist develop the outside of the box with as much care as the inside.

A sculpture and the space around it are adjoining volumes. The sculpture operates as a figure in the "negative space" (or ground) of the room. If you stand at any given point facing the sculpture and draw an imaginary line connecting the outermost points of the work, you can get a sense of the dynamic of this figure-ground relationship that is so particular to sculpture.

First observe whether you are drawing a relatively symmetrical box or one with extreme convex or concave thrusts. How does empty space *within* this outline of the sculptural form operate (if at all)? How does the empty space *surrounding* the sculpture affect our view of it? Is this imaginary solid shape larger on the bottom or on the top? If it is larger at the bottom is a stable pyramid-like shape created? If it is larger at the top, does it seem unstable?

What happens when a form is leaning at an angle? Does the extremity of the angle affect our reading? If the angle creates a wedge-like negative space beneath the form, what is the shape of that wedge?

What are the proportions of height to width? Are we looking at a long, flat, horizontal work that pulls our eye down and across the room? Does the empty space of the room seem now more noticeable, even hovering above the flat object? Is it a tall, narrow work that pulls the eye up? Does the form almost touch the ceiling?

Imagine:

Fifty flat steel plates that create a path on a gallery floor
Fifty pillows that create a path on a gallery floor
Stacked steel plates that form a column up to the ceiling
Stacked pillows that form a column up to the ceiling

The discrete sculptural object and the space that contains it are part of a symbiotic whole, much like shapes arranged on a picture plane.

Footprints

Every standing sculpture has a footprint. This is the shape created where the work meets the floor. If the sculpture were to magically disappear, what would its residual footprint be? Would it be broad and flat, or a scattered pattern of points?

Steel Rods

For a welding assignment each student is asked to begin with twelve ten-foot lengths of quarter inch steel round bar. One student constructs a box with a three-dimensional grid in such a way that twelve tiny legs raise the grid above the floor. His footprint is a regular grid of dots.

Another student cuts all of the round bar into six-inch lengths and welds these little sticks side-to-side and end-to-end to make a solid flat patterned plane. Her footprint is a solid rectangular shape.

Glue

In a special daylong project each student begins with a gallon bottle of glue. One student dips pieces of thick string into glue. She attaches one end of each string to the same spot on the wall and extends it out to a different place in the room. The footprints are scattered points around the room.

A second work is made by mixing the glue with blue pigment, pouring it onto plastic sheets, peeling the dried glue off, and discarding the plastic. The footprint is a massive, solid irregular shape.

A third student removes the top of his gallon jug, places a scrap of cardboard on top, turns the jug upside down, places it with the mouth against the floor, and carefully slides the cardboard out. The weight of the jug holds the glue inside as long as the jug is undisturbed. His footprint is a circle the size of the mouth of the jug.

Gravity

Formal choices are often dictated by the laws of gravity. An object's relationship to gravity changes if it extends directly up from the ground or cantilevers out at an angle into the room. Does a work require an additional support or is the form counterbalanced so that no other support is necessary? Should a support be visible? How do you integrate it into a piece?

Should you suspend it? If so, how far does it hang from the floor? Can it be up against the ceiling or an inch off the ground?

Suspended Pieces, Pedestals, and Prop-Ups

Although gravity can be marshaled or defied to give dynamic tension to a work, it can also pose practical problems for the artist. Returning

to our earlier discussion of how a formal assessment of a sculpture includes a consideration of where the object ends and the space around it begins, we turn our attention to ways in which a sculpture is lifted off the floor through a variety of devices. These are suspension apparatuses, pedestals, and prop-ups.

Suspension Pieces

Suspension allows the artist to defy gravity. When considering suspended objects in critique it is important to not only formally assess the sculpture but also the particulars of the suspension.

Suspension devices can be attached to the ceiling or a frame within a large space, which functions as a false ceiling. Possibilities for suspension devices are only limited by the artist's imagination and the physical qualities of the material used to suspend the sculpture. Whether a sculpture is suspended by an invisible fishing line or heavy rusted chain links, elastic nylon cord or rigid steel bar, we must first ask is whether suspension is the best solution or might the sculpture be better free standing. We also consider if the sculpture is suspended because of flimsy construction or if suspension is integral to the design and concept of the work.

Next, we should look carefully at the hanging mechanism itself. Is the hanging device a noticeable feature of the sculptural object or does the suspended sculpture appear weightless? Is the hanging device made of a material that makes it seem like an extension of the sculptural form? Is any hardware used? Is it visually prominent or is it hidden? Is the hanging device rigid or elastic? Is it noticeably thick or thin? Does the sculpture connect to the ceiling at several points or only one?

Notice the relationship of the suspended object to the floor and ceiling. Is the form hung in such a way that it hovers above one's head or is it at eye level? Is it so flush against the ceiling that it appears to grow from it? Is the hanging apparatus extremely long in proportion to the sculpture, so that the sculpture is hanging only a few inches from the floor?

Suspended sculptures can be positioned in dynamic ways and put in places that freestanding and even pedestal works could not inhabit. Critique of suspended sculptures requires a careful look at the sculptural form, the suspension device, and the uniquely dynamic position of the sculpture in the space.

Pedestals

Similar issues come into play when we look at sculpture bases. The conventional pedestal is a device that allows the artist to elevate the work off the floor—anywhere from a few inches to eye level—and here the work is seen as ending where the pedestal begins. Like a hanging device, the pedestal must be considered as part of the formal equation. When we talk about works displayed on pedestals, we have to ask, where does the work begin? Is it only above the pedestal or is the pedestal part and parcel of the whole? Is the pedestal fair game in our discussion? Or can we see it merely as a presentation issue, of concern only when the work is too large for its base or when the paint job on the pedestal is noticeably bad?

Indeed, if the sculpture is to be considered in its *entire* spatial context, we might see the pedestal as an extension of the floor—as if a chunk of the floor has risen up to make the work more readily visible. The most successful pedestal, like the perfect mat selection for a print, must either disappear, or operate as a conscious part of the work. In either case, the pedestal is no longer neutral.

Seeing the Pedestal as Art

Consider whether the pedestal is being used merely because it is a conventional means of display; or has it been custom fitted to display a work? What is it constructed out of? Is the choice of color or material so close to that of the work that the base becomes an extension of the work? Or is it painted to contrast with the presented work? Does the pedestal visually interfere with the work? Are its proportions unusual? Is it solid or open? What color is the pedestal? Is the color of the pedestal coordinated with the sculpture in some way? Is it transparent? Or painted white, black, or gray to echo the color of the gallery walls?

If the work displayed is a series of small sculptures, are they presented on a single large pedestal or multiple small ones? If the work displayed is large, is the pedestal hefty or has it been constructed to be small in relation to the displayed sculpture for possible comic effect?

How high is the pedestal? Does it raise the work to eye level or intentionally force the viewer to stoop in order to see the work? Is the pedestal impossibly high, requiring various sculptural props to allow the viewer to actually see the work? Is it impossibly thin (and secretly weighted at the bottom for stability), making the work feel precarious? Is it so bizarrely broad and flat that it operates as a false floor? Are there

so many low flat pedestals in the space that they almost fill the room and allow only a narrow channel for movement around them? Does the pedestal have legs, or is it solid like a wedge, a plate rising from the gallery floor?

Finally, is the pedestal a shelf that attaches to the wall or an alcove cut into the wall? How is the shelf attached or the alcove formed? What about size, shape, color, and positioning of these?

As we can see, the common pedestal is infinitely variable and should be carefully considered in critique as integral to the whole experience of any work.

Prop-Ups

When an artist constructs a sculpture with the intention of cantilevering part of it out over its center of gravity, but neglects to counterbalance the sculpture with the necessary weight or design it in such a way that it does not threaten to tip over, what we shall call the *prop-up* comes into play. These can literally be poles, sticks, or rods, or less obvious forms that serve the purpose. (Some hanging mechanisms are prop-ups in reverse!) These kinds of gravity-defying devices are encountered in critique when the artist asks the critique group to ignore the prop-up and insists that the sculpture ends where the prop-up element begins; the prop-up a desperate remedy for "night-before-the-crit" disasters! Whether artfully disguised or blatantly functional, the prop-up becomes an integral part of the sculptural form. As part of the formal equation, it must be part of the critique discussion.

Ratio

Ratio refers to the relative scale of the sculptural form to the room. A small form in a huge gallery draws us in for a closer look. An enormous form in a small space crowds our movement and resists our attempts to see it in its entirety. At times, a sculpture may be so large that its volume equals or exceeds that of the room. Imagine a pink inflatable sculpture so enormous that it fills the space and protrudes out the door.

The Room within the Room

Some sculptural forms create an empty interior space. Boxes and vessels are familiar examples. But, unlike a conventional box or a vessel, a sculpture with an interior space can be so large that it seems to be as much architecture as it is object. We might think of these as

room-within-the room sculptures. The sculptural object becomes a room within the gallery room—perhaps a literal room or some other interior space for a viewer to experience.

> *Imagine a silver bowl:*
>
> *the size of the palm of your hand.*
> *the size of your body.*
> *the size of your room.*
> *the size of your city.*

How do we talk about such interior spaces? We might first ask what is the scale ratio of the interior space of the sculpture to the space of the room? Can we enter it? Does it feel theatrical? Is there a sense of front and back stage? Is the exterior surface of the sculpture treated differently from its interior? Is the outside of the room within the room operating in the work like the back of a painting?

How do we read a series of hanging scrims that create a maze in a gallery space? Here the room within the room multiplies and fragments. The sculpture begins to move even further away from *object* and toward *architecture*.

The Decentered Object

Another way that an object can reach equilibrium with the space around it is through fragmentation and expansion. Individual parts that make up the sculpture are still discrete shapes, but are now combined into a large composition that fills the space or even meanders out of the room. Here the sculptural form is *decentered.* Such groupings may be made of parts varied in scale and shape or of identical units.

The decentered sculpture may appear as a seamless whole or as a less coherent group of fragments.

Objects and Fields

It's tempting to see a painting as either a portrait or a landscape, depending on the vertical or horizontal orientation of the canvas. Just consider the page setup window on your computer. The exception is the reclining figure, itself a landscape of sorts.

But let's consider for a moment the operation of the horizontal and the vertical in sculptural form. For most students, the vertical (a sculpture that is taller than it is wide) brings with it inevitable associations with the

upright human figure. Is this merely a function of width being less than height? Not entirely. For a sculptural form that is proportionately the same but oriented horizontally will likely be read as a reclining figure. Indeed, the folklore surrounding certain mountains sees them as sleeping giants because of a rough resemblance to the human figure. In sculpture, anything loosely constructed with human proportions seems to carry that association.

But what if the proportions of our elongated object are made more extreme? At what point does the proportion in relation to the human form stretch so far as to lose all relationship to the original referent? How far could it stretch vertically? If the ratio of width to height is 1 to 100 or 1 to 1000, what happens to the figurative reference? How far could it stretch horizontally? More important, at what point does the object's width expand (without a proportional expansion of its height) that it becomes a field—like a huge puddle, a spreading mass? When does a work made up of individual parts create *a field*?

Unlike painting, sculpture seems to become landscape when it is read as environment rather than object. When we speak of a field painting, the repeated figure or motif has a uniform relation to a painted ground. At the extreme, figure and ground form a seamless continuum, as in monochrome color field paintings. In the case of a sculptural field, the object either spreads or multiples to the point that the relationship of the object to the space (the figure-ground relationship) shifts radically. Fields are often realized through a development of the horizontal axis. If vertical sculptures seek to defy gravity by seeming to extend up from the floor, horizontal sculptures seem to hug the ground and expand by spreading across the floor. A small field on a large floor operates as a figure on the *ground* of that floor, even if within its own parameters it operates as a field. But even then, it carries with it the potential to expand to the edges of the space and beyond.

In looking at a field sculpture, observe the edge where the sculpture ends and the room begins—both in terms of the edges around the field and in terms of its depth. (In field sculptures, typically length and width are greater than depth.) We must consider the ratio of sculptural mass to floor space. Is the field of objects so dense that it begins to overwhelm and *become* the floor? What happens when it is so dense that it begins to stack up on itself and fill the room? We must also consider the nature of the field. Is it constructed out of a single unit or an accumulation of multiple units? Are the multiple units identical? If not, what do the units formally

have in common if anything? Color? Scale? Shape? Material? What is the size of each unit in relation to the overall size of the field? Are the units connected, and if so, how?

> *Imagine:*
>
> *Thousands of tiny figures covering a gallery floor wall to wall.*
>
> *A rectangular shape—eight feet wide, twelve feet long, and four inches deep—made with lavender buds.*
>
> *Hundreds of intertwined pink baby toys covering the floor and creating a sickle shape.*
>
> *Nine yellow plastic mats sewn together with yellow cords, configured in a grid on the floor.*

The Expanding, Exploding, or Meandering Form

A field is a kind of decentered object that can expand, explode, or meander. But whereas fields tend to appear as seamless wholes, other decentered sculptures are made up of less coherently related parts.

When a sculpture is made out of parts, configuration and reconfiguration are possible. A form can swell to fill a space or even spread beyond the room. A decentered sculpture can also appear as a series of ruptures or as fragments from a larger whole. Parts might be connected visually but not physically.

Sculptures made of multiple parts can be structured like atoms or molecules, where a little mass can create a lot of volume. If, for instance, we were to get a thousand Tinker Toy sets and create small constructions that we then scattered across the floor we would create a field. If we were to get millions of Tinker Toys and completely fill the volume of a room with our constructions we would also be creating a field. We have multiplied a single construction unit to the point that it loses its *objectness* and becomes a field.

However, what if we took a single set of these same Tinker Toys and magically magnified the parts so that each of the tiny discs was five feet in diameter and the connecting sticks as big as lamp poles? And what if we then filled the room with giant interlinking constructions? What if the structure was so big that we were unable to enter the room? Would our enormous Tinker Toy construction operate as a field? What about the inaccessible spaces that would be formed? Are these not part of the sculpture?

If we were to use found objects connected by wooden dowels, carved foam body parts connected by steel poles, or baggies of colored water connected by Plexiglas rods, the formal dynamics of our huge Tinker Toy sculpture would be the same.

Imagine:

Buckets of white river stones are used to create paths that lead through the various galleries and hallways of a big museum. The gallery and hallway have dark wooden floors.

Hundreds of pieces of furniture fragments, used plumbing parts, old bicycles, and other found objects are loosely bound together with heavy-gauge wire into a swirling form. The form seems to climb up the wall and then ducks through a window and continues on the outside of the building.

Identical chairs tied together with bungee cords to create a number of irregular forms. These are then tied onto the side of a railroad trestle at various points with some connected and some not.

Wide, long rolls of bright paper pinned, twisted, and repinned to all four walls of a small room until they fill it.

Whether field or exploded object, if the sculpture is constructed out of multiple parts, we should observe how these parts are integrated and attached to one another. If these parts are connected visually but not structurally, we should observe how these parts are placed in the room.

If we accept that no object is perceived in isolation, and that any given part is attached to the whole, then it follows that the relationship of parts to the whole, in a given sculpture, and the sculpture's relation to its site need to be considered in critique. In much the same way a figure in a painting operates very differently if it resides at the edge of the picture plane or occupies its center. A sculpture, too, can change radically with shifts in placement in relation to a room, a base, or in relation to other forms in a space.

Formal Considerations within the Object

We began our formal critique of the sculptural object by looking at its *relational* formal qualities. We considered a sculpture's relation to the space around it and to other sculptural forms. We then considered how positioning, orientation, and display inform the dynamics of an object in space, and how sculptural objects through shape and accumulation can

operate like fields. But what about the object itself, what it's made of and by what means?

Mass and Shape

Let's begin with a singular form. We can look at it from an infinite number of views. Imagine if we circled around an object taking snapshots and reducing the images to simple silhouettes. This would be one way to observe how the shape of the sculpture shifts with changing viewpoint. Our silhouettes would also mark the edges of the sculpture. Once again, we would consider where the sculpture ends and the space around it begins from multiple perspectives.

To consider how mass comes into play in sculpture we can go back to our high school physics book. Mass is defined as "a quantity of matter in a body, and is a measurement specifically of the inertia or sluggishness that a body, in the absence of friction, exhibits in response to any effort made to start it, stop it, or change in any way its state of motion."[9] Mass and weight are easily confused because they are directly proportional to each other. Mass is not the same thing as volume, however. Even though we might commonly refer to something large as being massive, a massive object is not necessarily large at all. A solid lead block, plaster block, and a Styrofoam block vary widely in mass even if they are equal in volume. Density is the relationship of mass to volume, and it is density that most often comes into play in the formal language of sculpture.

A sculpture built with a hollow shell may look like a solid form but is really operating with maximum volume and minimum weight. A form made with an armature that has been surfaced renders a hollow object that appears to be solid. Other examples include inflatables, which are skins, but like cast bronze figures are perceived as solid. Inflatables allow a sculptor to work with very large forms that can operate as solids, but without the problems of unmanageable weight. Large-scale traditional bronze casting is hollow for this reason. A hidden hollow interior reduces weight, expense, and is more compatible with the requirements of the casting process.

For some sculptors, mass and weight are critical to the work and lighter weight, large elements are not acceptable. Indeed, for those sculptors who insist on a certain *truth* to the materials (we will discuss this later in the section on materials and processes), the very idea of a hidden volume or faux finish on a light material is

objectionable. For others, materials and processes that allow for large volumes with little weight offer formal options that would not be possible otherwise.

In critique, these questions will inevitably come up as we question an artist's material choices, both in relation to how well the artist has realized the illusion of solidity, and how the use of illusion impacts our reading of the work. If the artist's *intention* is to depict a solid form and the underlying support is showing, this could become a reasonable formal complaint. We might well ask if part of the sculpture's power is in its sense of weight and density. Is this lost when we see the evidence of the chicken wire pattern beneath the surfacing? Are there unintentional holes in the surfacing that allow a peek into an interior that has not been considered? Most people don't like to think of the bronze hero in the park as being hollow.

We should note here that a hollow space can be celebrated and explored in a number of ways. A form can be cast in a transparent material. An armature can be covered in a transparent skin. In this way, the interior space becomes an active part of the sculptural form whether it remains empty or is filled with various materials or objects. Remember the series of imacs that were encased in transparent plastic, revealing to all the computers' inner workings.

MATERIAL AND PROCESS

The dictionary definition for mass is "a coherent body of material not yet fashioned into objects of definite shape."[10] A *material* is typically thought of as the matter out of which a sculpture is made. And any given material in sculpture brings to the equation its particular physical properties, which become central to the work. (That materials also carry their own meanings is something that will be considered in the next chapter.) A material behaves, or can be made to behave in a particular way, as an artist works with it. The artist's process is directly informed by the physical properties of a material being used, whether by following its natural tendencies toward a final form or by subordinating it for the sake of a predetermined idea.

Thus, material and process are often linked in an improvised dance of calls and responses, resistance and submission. Sometimes the material drives the process in the work. Clay is malleable, stone is hard,

steel will bend in a way that is different from wood. Some materials can be cast as liquids and hardened to solids. Others can be tied, ripped, or poured. A material can be chosen because it is the best choice for the artist to realize an imagined form, but material and process can also influence the concept. This can happen when an artist has a personal affinity for a material or process or when the artist starts with a raw material that guides the sculpting process and ultimately the resultant form.

Modeling, Casting, and Carving

For many contemporary artists sculpture still *is* modeling, casting, and carving. Artists continue to employ traditional materials like clay or wax because of the plasticity these materials offer and the ease with which they can be modeled into a range of forms. Since prehistory, soft clay has been modeled and sun-dried or hardened and fired to produce sculptural forms. Fired and unfired clay remains a viable material. Oil clay, which does not need firing, can be used to make molds or finished works. Clays that can be fired in home ovens and easily painted have been brought into the artist's studio from the world of kids and hobbyists. The modeling process has been expanded by contemporary sculptors to include pliable materials such as bubble gum, bread dough, and even feces.

If modeling is traditionally thought of as an *additive* process, then carving is *subtractive*. Wood and stone have been used traditionally because of their availability or longevity, but carving is possible with almost any material, including laminated Styrofoam sheets, soap cakes, graphite blocks, and even ice. The surface of a carved form can be left as is, the identity of its material exposed. Or it can be treated to resemble some other material, such as cast plastic or metal, or just about any other illusionistic surface imaginable.

Modeled or carved forms can be used to make molds. These can be cast to make sculptural objects out of any number of materials from bronze, to plaster and clay slip, to plastics. One can cast and freeze or refrigerate almost any liquid material to produce a solid—water, Jell-O, Kool-Aid, even blood.

If a work that we are looking at has been modeled, cast, or carved, first note the material employed. Is the material readily apparent? Or has it been intentionally hidden? Is it foregrounded or treated as a given?

In critiquing modeled or carved work, we might first ask whether this is operating as a carrier for an image or as a material or both? A simple ball of bubble gum might be more about the material than the particular shape. Would another shape be better? Should it be bigger or smaller? A wooden head, carved with attention to the grain, might lead to a discussion about the way the undulations of the surface operate with the pattern of the wood. The same wooden head painted and sanded to a smooth surface would be less about the wood and more about the form and the paint handling.

What about craft? If a sculpture shows evidence of having been skillfully modeled but is so poorly cast that much of the detail is lost, we may take issue with that. If the mold-making process goes well, but poor modeling skills have undermined the original and thus the final product, we have a valid complaint. In looking at works that have been modeled or cast directly, consider how both processes come into play. Has each process worked independently and how have they been orchestrated toward the final product?

There are as many things to consider in a critique as there are processes open to artists. Was the mold taken from a clay or wax positive, or was it made directly from a live model or a found object? Was the mold made from a found object altered with clay additions or has it been cast in order to reproduce the original object but out of another material? Is the work in front of us that looks like a kind of crude cocoon made with plaster bandages that have been laid wet over an object or human model, or did the artist model an original positive? Is the work that has the appearance of an authentic artifact made from a mold taken from life? Depending on the artist's modeling skills, there is great potential in the modeled original, not only to invent form but also to play with verisimilitude and scale in disturbing ways. There are no hard and fast rules as to which approach is likely to yield a successful work. Thus, a critique, which begins as a formal look at what is in front of us, often becomes a fact-finding mission as to the artist's process and materials.

Construction

Construction is a relative latecomer in the Western tradition of sculpture. Many of the concepts that we covered earlier in our discussion of objects in space are relevant in discussing the constructed object. In short, when we think of a constructed object in the most basic way we are talking about building and joining.

The list of potential materials and processes that fall into the category called *construction* is endless, and we are as likely to use materials from the world of industry as from traditional art suppliers. Steel fabrication has joined and often replaced the bronze foundry. Wood, once carved, is now used to construct. Thin strips of wood are laminated into complex curves. Flat sheets of plywood, foam, and plastic are cut from patterns and glued and stacked to create forms that look modeled. Dowels are tied, taped, glued, drilled, wired, woven, and more. The list goes on. Anything that can be used to build *is* used—sheets of rubber, felt, fabric, copper and Plexiglas, metal, plastic pipe, wire, rope, and shredded paper. Cast, carved, and modeled parts are often used in constructions.

Given the dizzying array of possibilities, how do we look at constructed works in critique formally? First, list the materials used. Is one material employed or several? Is one construction process employed or several? Next, note the shape of the sculptural object and its relationship to the space around it. Describe this. Consider shape. Are there areas of density and open space?

Because each material or process brings its own set of standards to a critical discussion, we should consider each on its own terms and try to determine whether a problem comes from a lack of mastery of that material—the welds are bubbly, the wood is split, the duct tape has hair in it—or whether these are the most appropriate or only possible materials.

Material and Process as Form: From Adjective to Adverb

With any sculpture, the physical properties of the materials used to make it have an impact on the way it is built and seen. Indeed, the materials themselves seem to drive the process of construction emphatically and are integral to the final form. These are sculptures in which, for example, wood is not sanded and surfaced to look like plastic, fiberglass is not painted to resemble flesh, steel armatures are not covered in screen and paper pulp to appear as stone, and Styrofoam is not faux-finished to become marble. Rather, the weight, color, texture, plasticity, or other qualities of the material are revealed and even emphasized.

An artist working this way is less interested in using material in the service of an image (even if this image is an abstract form) than in letting the material lead to the final form and the final meaning. The

integrity of the materials is as important as the surface appearance. For all practical purposes, in works like these, the material/process *is* the form.

Material as Action

Consider a conventional art material like plaster. In traditional sculpture, plaster operates almost completely at the service of image, such as a three-dimensional hand or bust. But what if a plaster sculpture's sole purpose were to communicate its *plasterness*? What if the explorations of the plaster's physical properties—smoothness and texture, the time it takes to set, and its inherently subtle variations in color—are *foregrounded* in such a way that the sculpture exhibits all the marks, actions, and stages of its construction? To formally assess works like these, we might find ourselves describing scraping, gouging, smoothing, pocking, and pouring.

Indeed, sometimes in critique, the materials and processes play such a dominant role in our formal assessment that we are led naturally back to descriptions of process. Thus, in addition to adjectives that describe material properties, such as transparent, dense, large, small, heavy, weightless, colorful, dull, textured, or smooth, we can describe the work as stacked, twisted, pinned, poured, torn, ripped, bound, splashed, spread, or woven.

Material and Illusion, Material and Integrity

When we look at a sculpture in critique, we should consider if the artist has transformed one material into the illusion of another. Are we seeing apparent weight or real weight? Does the sculpture in front of us have the *appearance* of density or is the form actually dense? Does that steel plate really lean against the wall or is it attached with hidden brackets? Is that massive bundle of sticks solid or is there an armature hidden inside that gives the illusion of density?

For some artists the avoidance of illusion is not just an aesthetic choice, but one that is inseparable from the integrity of the work. A sculpture like this formulates its own rules of authenticity. What you see is what you get. Nothing is faked, and there are no disguises. The color of the sculpture is the color of the material. Parts are supported by their own accumulation, not by armatures or frames. The artist allows the properties of the chosen material to take center stage rather than a supporting role.

We have seen that a formalist critique is one that limits itself almost entirely to a discussion of structure. The conversation revolves not around *what* the work says but *how* it is said.

There is value in beginning a critique with a focus on formal matters. Indeed, some works may be so politically or personally charged that objective analysis is almost impossible without first bringing to bear on the work the cool eye of formal assessment. However, any critical discussion that limits itself to formal concerns to the exclusion of relevant content begins to seem absurd. How can we describe a painting in terms of palette and composition if we fail to mention that the painting is a depiction of horrific torture, and that it was painted by an eyewitness survivor? How can we describe the sublime lighting and beautiful sound score of a video installation if we fail to acknowledge that the footage is from night vision shots of aerial bombing? How can we limit our discussion to proportion and light source when faced with a female nude in a clearly pornographic pose? With this in mind, we now turn from formal matters in a work of art to consider the story it tells.

NOTES

1. *Mimesis* is simply the Greek word for imitation. Plato and Aristotle both use the term extensively in their writings about art, in the sense of to *represent* by means of imitation.

2. In the 1930s, a group of New York artists formed an avant-garde group, calling themselves *the Ten*. The group included Mark Rothko, Adolph Gottlieb, Ben-Zion, Joseph Solman, and others. Disagreements over political issues as well as abstraction versus figuration caused the group to disperse in the late 1930s. Rothko split off from the Ten to join Pollock and other artists exploring abstraction.

3. In his essay *Modernist Painting* (1961), Greenberg echoes Bell's assertion that form is of primary importance in judging even representational work. He points out the revived reputations of such painters as "Uccello, Piero, El Greco, Georges de la Tour, and even Vermeer," going on to say, "but Modernism has not lowered thereby the standing of Leonardo, Raphael, Titian, Rubens, Rembrandt or Watteau. What Modernism has made clear is that, though the past did appreciate masters like these justly, it often gave wrong or irrelevant reasons for doing so." Greenberg, C., "Modernist Painting" (1961 revised 1965), in Greenberg, ed. J. O'Brian, Vol. 4, 1993 (VIB4), also found in Harrison & Wood, p. 760.

4. *Masters of Modern Sculpture Part III: The New World* (1978), directed by Michael Blackwood, written by Edward Fry and Nancy Rosen, Michael Blackwood Productions, Inc.

5. Hoffman, Malvina, *Sculpture Inside and Out*, New York: W. W. Norton, 1932, p. 52.

6. Aristotle, *Poetics* (with an Introduction by Frances Fergusson), IV, trans. S.H. Butcher, New York (1961) pp. 55–56.

7. Kirk Varnedoe, an eminent curator and art historian, organized the 1998–99 retrospective of Jackson Pollock's work at New York's Museum of Modern Art. This anecdote comes from Jeffrey Brown's interview with Varnedoe in a news story about the Pollock retrospective for the *NewsHour with Jim Lehrer*, broadcast January 11, 1999. "Jack the Dripper," Jeffrey Brown, *NewsHour with Jim Lehrer*, MacNeil/Lehrer Productions, January 11, 1999.

8. Greenberg, Clement, *Abstract, Representational, and So Forth* (1954), in *Art and Culture: Critical Essays*, Boston, 1965, p. 133.

9. Hewitt, Paul G., *Conceptual Physics,* pp. 21–22, Little, Brown, and Company, San Francisco, 1971.

10. *Oxford English Dictionary,* Oxford University Press, 1971, Nineteenth printing in the United States, March 1980.

Chapter Two

The Story It Tells

MEANING

Meaning Is Not Absolute

This section might more accurately be called *the stories they tell* because meaning can never be completely contained in any work of art or in any one of its parts. Although we immediately think of meaning as something that resides comfortably in a work's narrative imagery, it is really a slippery, shifting thing, informed also by a multitude of formal choices made by the artist—when and where a work exists, what it's made of, how it came into being, who made it, and what is carried to it by the viewer. Meanings can change as a work ages, as a political controversy swirls around it, or as information emerges about the artist's life, earlier works, intentions, process, or even personal habits. That isn't to say that a work of art is beyond interpretation, but simply that meaning can never be finite or stable.

Signification

When you hear people using the term *signification* in relation to works of art, they are talking about interpreting its *meaning*. The idea that *meaning* is something that is carried around by a work, like a passenger on a train, is more complicated than it first appears. This can be illustrated by looking at spoken language, where seemingly clear and unambiguous statements can have different *meanings*. In his book *Literary Theory: An Introduction*, Terry Eagleton elegantly illustrates this in the following passage, using a simple linguistic command, *close a door*:

> Let's go back for a moment to the situation I outlined earlier, where I tell you to close the door when a gale is howling through the room. I said then that the meaning of my words was independent of any private intention I might have—that the meaning was, so to speak, a function of the language itself,

rather than some mental process of mine. In a certain practical situation, the words just do seem to mean what they mean whatever I might whimsically want them to mean. But what if I asked you to close the door having just spent twenty minutes roping you to your chair? What if the door was closed already, or there was no door there at all? Then, surely, you would be quite justified to ask me: "What do you mean?" it isn't that you don't understand the meaning of my *words*; it is that you don't understand the *meaning* of my words. It will not help if I hand you a dictionary. Asking "What do you mean?" in this situation is indeed asking about the intentions of a human subject, and unless I understand these then the request to close the door is in an important sense meaningless.[1]

The point Eagleton makes is that *meaning* is never absolute. In Eagleton's scenario, the meaning of the command, "close the door," keeps shifting as the situation around the statement changes. Hence, meaning depends on who is speaking, where they are, who is being addressed, how the message is delivered, and a whole variety of other circumstances, including the weather.

As in language, a work of art may simply be read by what the viewer sees (a soldier or potted plant). However, as in spoken language, signification in a work of art is created by a complex web of operations that includes art history, formal choices, the artist's stated intentions, how the work was made, who made it, and the context in which it is shown.

Denotation and Connotation

Let's say that in a critique, a student presents a carved Styrofoam sculpture that everyone in the class recognizes as an axe on wheels. If we were to ask, "What is it?," everyone in the critique group would no doubt answer, "It's an axe on wheels!" But if we were to ask what the sculpture *means,* we would be unlikely to say that it is *about* an axe on wheels. We would try to understand the work by moving from what the form *denotes* (an axe on wheels) into what it *connotes*, that is, the possible meanings we can attach to the combination of wheels and axe, presented in this particular way at this particular time to this particular group. Thus, the sculpture might *denote* an axe on wheels, but it might *connote* the end of colonialism or the destruction of the rain forest. These can be useful terms when looking at how meaning operates in a work of art. The one is what we plainly *see*, the other is what we can *read* into it.

For most students, it is easy to see how narratives can operate in realistic painting or sculpture, much the way they do in novels or poems. Modernist thinking rejected the notion of art produced to the service of story (one does not make a painting or sculpture *of* anything, rather one paints, one sculpts!). Postmodernist thinking has reembraced the notion of art as a carrier of information, a narrative, a complex system of signs, in other words, a language.

Let's return to our axe-wheel sculpture. The form *denotes* an axe on wheels, but the connotations in operation would not end there. Does the tilt of the form suggest the movement of a motorcycle rounding a corner? What if the sculpture is constructed out of carved Styrofoam, placed on a Styrofoam base and then both sculpture and base are surfaced with a faux bronze finish? Would it not then also read as a monument? Given that it is not a real monument, but a fake one, could we not say that the connotation goes even one step further, and that the sculpture behaves as a kind of spoof on monuments? What if our axe and wheel, faux bronze monument is carved in such a way that it looks like an animation character? How would the combination of axe on wheels, motorcycle tilt, cartoon, and bronze monument add up to produce meaning in the work? What reading might it evoke?

Even if everything else in the sculpture remains the same, if we change the surface treatment, this will again radically alter the meaning. Instead of faux bronze, imagine our carved Styrofoam axe on wheels surfaced to a perfect smooth finish and painted in bright cartoon colors. Imagine it textured to look like concrete, or covered in thousands of tiny magazine clippings with images of a recent military conflict. The possible connotations are as endless as the options.

Content and Subject Matter

Content and *subject matter* are two terms that are sometimes confused in critique. Subject matter is *denotative* and content *connotative*. To differentiate between the terms *subject matter* and *content*, consider two still lifes. Both are of a vase of flowers on a table in a room. There is a window on the back wall with a view of a landscape. The first work is painted in bright colors, with the flowers reaching up toward a light ceiling. The window behind the flowers reveals a pastoral landscape. The other is also a vase of flowers on a table, but the table is cracked and painted with washes of brown. The flowers are wilted, a few of them snapped off, and the window looks out on a dark, barren landscape.

Both are still lifes with flowers in a vase on a table in a room whose back wall reveals a window to the outside. These things in the painting are its subject matter. But each has a very different *content* or *meaning* for the viewer. The difference derives not from *what* the artist chose to paint but from *how* the work was painted, that is, a series of formal choices, made by the artist that have created meaning.

Three Crucifixes

In his book *Learning to Look,* Joshua Taylor[2] uses two paintings of a crucifixion to illustrate how the same subject matter can be painted to yield very different *expressive content.* One is by Pietro Perugino and the other by Carlo Crivelli, two Renaissance painters from a similar time doing paintings of the same subject. Perugino's crucifix is taller and lighter than that in the Crivelli, which seems heavy and closer to the ground. Color in the Perugino appears in discrete areas and tends to be saturated, whereas Crivelli's landscape is broken up into sharp facets of middletoned earth colors, giving the painting a depressed and disturbing feeling. A thorough formal analysis by Taylor reveals that although both paintings are ostensibly of the same subject, the Perugino clearly emphasizes Jesus' divinity, pointing everything upward, and away from mortal suffering, creating a sublime experience for the viewer. The Crivelli is the opposite. Jesus appears heavy, as does the cross, and close to the ground, which appears sharp and threatening. Whereas the Perugino points hopefully toward resurrection, the Crivelli is an essay in the mortal suffering Christ endured for man's sins. In each case, particular formal choices applied to the same *subject matter* created two disparate meanings.

Now let's take a contemporary (albeit controversial) crucifixion, Andre Serrano's *Piss Christ.* Serrano placed a small figurine of Christ on the cross in a jar of urine and photographed it. Although the subject matter is still a crucifixion, the content is once again quite different from either of the masters' paintings. Despite it being a lightning rod for controversies over public funding for the arts, the *meaning* (or content) of Serrano's work is not so black and white. We might ask ourselves is the message *prescriptive* or *descriptive*? Is the artist trying to show us a picture of the way things *are* or the way things *ought to be*? Is the message that Christ *should* be in a bath of urine, as it was interpreted by several government officials who disparaged it? Or is Serrano using the crucifixion as a metaphor for the sorry state of society, thus,

saying something to the effect that Christ represents pure goodness and right now, because the world is so corrupt, he and Christianity as a whole are degraded? It's as if he were contained in this jar of human excrement. This *descriptive* reading of the Serrano would turn the meaning on its head. Clearly, meaning generated out of formal choices also comes up against our own guesses regarding the artist's intentions. Distinguishing between a work that is *prescriptive* as opposed to one that is *descriptive* becomes especially critical in the reading of works with highly charged subject matter.

The Loaded Message

Some subject matter is so strong that it overwhelms formal elements and context. Images that are violent, disturbing, or socially taboo, for instance, will monopolize a viewer's attention. Even if housed in relatively conventional media or formal structures, the *subject matter* will become almost synonymous with the work's *content*. Do we care if the figures are anatomically correct if the work takes us right to a scene from a recent war? Do we worry about lighting or print quality in a photograph that makes each of us a witness at the side of a mass grave? Or, conversely, is the effectiveness of the message inseparable from the effectiveness of the means? As when viewers are distracted from an optimum reading of a work because the craft is so poor?

Is some subject matter so loaded that we are unable to offer an objective critique? How do we deal with a bad painting or a poorly constructed shrine when we know that it is a personal tribute to the artist's lost loved one? In such cases, do we feel hesitant and insensitive pointing out formal flaws even if they interfere with our reading? Work based on personal issues and suffering or based on a student's social identity can be minefields in critique. What happens when a student puts up work that tells a story that is so personal and so loaded that the line between student and artwork begins to blur? Critical commentary may be mistaken for a personal attack.

Self-Portrait

In one critique, a student brought in a series of self-portraits with disturbing facial cuts and bruises. She revealed that she had a personal history of abuse and talked about her therapy, how this was an important issue for her, and so on. To criticize the paintings became a criticism of this brave act

of speaking up. In a sense, to commit verbal battery on top of everything she had already suffered. The instructors and peers in the room became completely disempowered. A purely formal critique—focused on clear strategies for depicting the subject matter—followed, while much of what was really on people's minds went unaddressed.

Finally, an old school modernist painter accused the student of being an illustrator, which brought her to tears. Other faculty and a few students cited social-content painters in her defense. But much of the conversation remained far from the work itself and steered clear of the most interesting issues.

By the same token, work about identity (gender, race, sexuality, ethnicity, handicap) can also leave the critique participants declawed, for fear of appearing insensitive, sexist, bigoted, or the like. With these works, it becomes difficult to speak without addressing the delicate and potentially controversial issues that the work provokes. Given that it is often the artist's intention to create a certain discomfort in the viewer, a critique that evolves into a heated discussion can be more productive than one that ignores the issues. Nevertheless, in some works confrontation is neither intended nor welcomed by the artist. How much should it then drive the critique?

Can one love the message and hate the form? Or hate the message and love the form? Imagine a work that addresses a political position with which you agree, but the work is badly drawn or poorly crafted, and the allegory is too obvious. Here, the message is so easily read, so accessible, that the artist's position has been presented without any risk of miscommunication. Contrast this with a work about the same thing, which is well crafted and so formally inventive that it is much less readable. Or what about a work of great beauty that celebrates fascism or hatred?

The Loaded Messenger: How Meaning Is Affected by Who Tells the Story

Some might argue that the identity of the artist should not influence a work's meaning. Indeed the idea that the interpretation of art be reduced to a biographical case study seems misplaced, at best. Still, there are works in which the identity of the artist is part of the content of the work and, in some cases, *the* most important factor in determining its *meaning*. Part of this is the perspective that works of art do not spring out of thin air but are the products of individuals who are themselves operating out of certain cultural and historical experiences. The artist's

gender, ethnicity, culture, and any other factor that informs his or her perspective have to be seen as critical components of the work, as long as they're visible or known.

Imagine that the critique group is looking at a painted portrait of a woman sitting against a red background. We can look at it formally, consider its composition, scale, paint-handling, accuracy of proportion, and how the bright red single-tone ground operates against the figure. We can determine that the brush strokes are almost invisible and that the warm light and cool shadow on the figure are painted to produce a convincing illusion of three-dimensionality in the arms, torso, neck, and face. We can consider the expression or gesture of the figure and speculate as to whether the person in the portrait seems sad, content, pensive, or is in formal pose. Is the identity of the figure important to our reading? If not, then our reading might end here.

What if we find out that the figure in the portrait is a Rwandan genocide victim? Would it be important that the artist knew the individual? Would it be the same work if the artist had never set foot in Rwanda and had worked from a newspaper photograph? Would the fact that the artist was Rwandan influence the way we read the work? Or French? Would it matter if this turned out to be a self-portrait of someone whose entire family had been wiped out in the genocide? Or painted by someone whose father had taken part in the killing?

What about a portrait of man in minstrel-show black face? We would certainly then want to know more about the motives and identity of the painter. Is this meant to be offensive? Does the painter identify with the man in the portrait? Is it a self-portrait that is meant to critique racial stereotypes or a personal gesture with complex social and psychological implications?

Now consider a painting of a nude. What if the nude is a woman lying face down in an empty lot? Does our interpretation change when we find out that this is the work of a large man with a deep voice as opposed to a soft-spoken female artist?

These are extreme examples but they allow you to see the way meaning can shift according to who tells the story.

Objectification and the Other

When one person uses another person (or people) as the subject of her work, she is already objectifying them to some degree. Whether the artist is trying to expose a social inequity or is simply attracted to the

look of a particular face, she has put someone else's image in the service of her own work. Is there a difference between painting a paid studio model and a paid homeless person in the park? A male artist painting a nude female and a female artist painting one? Or a female artist painting only nude males? Are there rules for who can represent whom? Must an artist speak only from his own experience? Self-portraits aside, images of people in most works of art are of others. When is this irrelevant to the interpretation of the work and when is it central?

How *do* we read works with images of people who are of a different gender, race, or culture than the artist? In many critical circles, the noun *other* has been turned into a verb; thus, someone can *other* another person. Objectify them. *Othering*, according to this way of thinking, can occur over gender lines, racial lines, economic lines, or cultural lines. These lines are inexact and shifting, for people's identities are comprised of many intersecting circles of affinities, which can connect and disconnect them from overarching categories, such as race, gender, nationality, poverty, and so on.

One way to think about it is as a dichotomy between power and powerlessness, where the less powerful can be *othered* by the more powerful. The idea is that culture and language are configured in such a way that the more powerful occupy a kind of neutral position; they represent the norm, if you will, and everyone else is, to greater and lesser degrees, an *other* of some kind. Thus if a white man paints a picture of a white woman, he has *othered* her by means of gender. If the same man paints a picture of a Native American woman, he has *othered* by gender and by ethnicity. How do these concerns play out in the interpretation of artworks?

When we speak of someone who is *other* than ourselves, even if our intentions are noble, do we risk speaking *for* them? Are we, each one of us, *other* in some way to everyone else? Or do particular affinities such as gender or race take precedence in certain debates?

The Indignity of Speaking for Others

Martha Rosler, in 1974–1975, did a work called *The Bowery in Two Inadequate Descriptive Systems*, the subject of which was a poor neighborhood on the lower east side of New York, where a lot of homeless alcoholics and drug addicts congregated. The work consists of photographs of storefronts that alternate with separate texts that list words having to do with inebriation. The texts are neither *captions* of the photographs, nor are the photographs *illustrations* of the texts. And

there are no people in the photographs of the storefronts. Rosler is presenting two distinct descriptive systems, neither of which adequately tells the whole story.

What is this strategy all about? She is, in essence, trying to make a work about the Bowery, without objectifying her subjects (creating *victim art*) or even speaking on their behalf (photography as social work), because that would, as she sees it, make her an agent of the system that has silenced and marginalized them in the first place. In Rosler's work, the *who* is part and parcel of the meaning, and drives the formal decisions. The positioning of her privileged eye is further complicated by the fact that she is a woman looking at men.

The Female Nude

If you were to hear that a student presented for critique a painting of a nude female, this would probably sound like a relatively neutral statement. You would likely imagine a critique of a painting depicting a studio model, which focused on light, shadow, composition, line quality, modulations of tone, and above all accuracy of proportion.

What if this female figure is positioned in a seated pose facing the viewer, hands clasped behind her head, and legs spread apart? We *could* describe the painting formally. "The painting has a symmetrical composition. The centered figure creates a strong vertical axis interrupted by a horizontal axis in the top half of the picture plane and a triangle in the bottom half." We could call it a female nude, and limit our comments to proportion, the modulation of light and shadow, line quality, key, palette, and paint handling. Would this feel normal or ridiculous? Who in the critique group would see the painting as a nude figure study and who would see it as a scene with a naked woman? What if you now learn that this is a self-portrait? How will this affect your reading? What if you discover that this is a painting by a male student of his ex-girlfriend? What if it is a painting by a female student of *her* ex-girlfriend? Or an older male student of his daughter? Is a nude ever *just a nude*?

Long hair

A student brings to the critique a nondescript wooden table, a chair, and a small beautifully made wooden box. She arranges the table and chair in a corner of the room facing out and places the box on the table. Everyone is curious about what is in the box. She asks to be scheduled at the end of the

critique day. When it is her turn she takes her place behind the table. She is nude. She opens the box and takes out a brush. The inside lid of the box has a small mirror that is visible to some in the group. She brushes her hair for what seems like a very long time. Her hair is waist length. Just as the group begins to get restive she takes out a pair of scissors and closes the lid of the box. The group gets very quiet. She then proceeds to chop her hair to a few inches from her scalp. Everyone gasps. She walks out of the room. Later in critique everyone is silent at first. Someone asks if she had always had long hair and how long did it take to grow it. Most of the conversation centers around the irrevocable nature of the action. That it is performance, but it is *real*. No one asks if she made the box. (She did.) Some of the students know that it is her fortieth birthday. But they don't say.

The Persistence of Nudity

The female nude is still one of the most common sights on the studio walls of many art schools, and figure study remains a mainstay in the development of a student's drawing skills. Let's take a moment to consider the nude itself. Although the study of the figure is less and less central to the training of artists, the rendering of the nude is still a staple of most drawing courses. The tradition of rendering the academic nude has come down to us from the Renaissance, inspired itself by Roman fresco and Greek and Roman statuary. The nude was an idealized human form, whose power rested in the idea that man was created in God's image. Indeed, the Greek gods, where the tradition begins, were imagined as very humanlike beings, that ate, drank, argued with one another, and even had love affairs. The incredibly proportioned images of these gods, found in temples and freezes, such as the Elgin marbles, must have seemed magical to early Renaissance artists as compared to the flat symbolic forms of their predecessors. Accepted by Christian theologians as an idealized embodiment of the divine and embraced by humanists as the preferred instrument for illustrating man's centrality, the tradition of the nude and the tradition of painting and sculpture have been inseparable.

Rigorous training in the rendering of the human form was then at the core of an artist's training and has remained so until recently. But what has perhaps been overlooked is that an artist's facility in depicting the nude was a means to an end, the end being a mastery that enabled an artist to create narratives, with humans at their center. What we now call academic figure drawing and painting often focuses solely on accurate rendering and good composition—the creation of *nudes for nude's sake*. An instructor thus might caution students not to think about content

until after they have perfected their skills in representing the figure, and tend to avoid discussions of content in critique.

What Is a Nude?

In his famous television series and accompanying book *Ways of Seeing*,[3] art writer John Berger takes issue with the art historian Kenneth Clark and differentiates between the terms *naked* and *nude*. A naked person, Berger argues, is a person without clothes; a nude, by contrast, is a person whose nakedness is worn as a kind of disguise. This *disguise*, he insists, turns the naked model into no one in particular. Thus the nude, by definition, is implicitly a form of dehumanization.

Four Female Nudes

Four students present work in critique. First up is a quiet soft-spoken young man of about thirty with long hair and non-descript clothes. He presents a painting approximately six feet by four feet. The painting is of a nude female figure rendered in an old masters technique. The student's drawing skills are evident in the work, the figure's proportions are almost perfect. Layers of glaze have been applied to create her transparent luminous skin. The figure is posed to look sexually provocative, and indeed the artist shares with the group that the title is *Miss December*. A debate erupts between two students over whether he has worked from a model or a photograph. One asserts that the best figure painting is done from life, and he is sufficiently impressed with the work to propose that in spite of the title it *must* be drawn from life. Another argues that the whole point is that the artist has ironically appropriated a centerfold and reconfigured it into a gorgeous classical painting. Three women in the room say that they think the painting is offensive, but three others declare it to be wonderful and funny. The artist scowls and mutters, "some people should lighten up."

A second student presents a work. He is a tall twenty-four-year-old, with teased blue-black hair, knee high boots, and a shirt unbuttoned to his waist. Most everyone in the class suspects that he is the lead singer in a band, but it can't be confirmed with any certainty. The painting depicts a nude female, done in bold expressive gestures over a dark paynes gray ground, creating an emotional space that is at once dreary and theatrical. The nude figure is squatting down, facing the viewer, with arms raised and palms out. Much of the conversation centers around the paint handling, which most agree is quite good. Again, a few of the women ask, "What is with the nude women in this class?" The artist politely begs everyone's pardon but defends his work by offering that the woman in his painting is a mythological character, who he calls Lilith, and that she has nothing to do with any of the *modern* women in the room.

A third student presents work. She is a short, stocky sixty-five-year-old with clear blue eyes and steel gray hair. She presents a series of twelve drawings. They are clearly self-portraits. In each, she is standing very straight and looking directly out. All of the poses are identical and each drawing differs only slightly. When someone in the critique group notices that each drawing is dated at the bottom, it becomes clear that the drawings were made over twelve consecutive days. Discussion follows as to whether this is a kind of visual diary, and what that might mean. Some students are skittish about bringing up the clear anatomical problems in the figures. Surprisingly, the student with the perfectly rendered, old master nude solemnly and seriously suggests that the work is about redefining beauty and may be about incremental passages of time. He also declares the drawings to be quite beautiful, both in terms of their formal choices and their subject matter.

A fourth student presents work. She is of medium height and wears stiletto heels, a tiny red leather skirt, and a very tight pink sleeveless sweater. She presents three large color photographs, all of which are self-portraits, shot from above. In all three, she is naked and looks directly at the viewer. In one she is lying on what appears to be a green satin sheet and holds a green rubber snake close to her face. In the next she is lying on a bright pink furry background and balances a tall layer cake on her stomach. In the third she is lying on a black rubber mat and holds a whip, with arms extended. Everyone in the critique group agrees that the works are intentionally erotic, citing her expression, her lack of clothing, and her pose. A few are confused by the work, and say that she is degrading herself but that she also seems very powerful. Others counter this might be the case if the photographs were someone else's work, but the fact that these are self-portraits makes it different. Most agree that the photographs reference soft-core pornography. A discussion develops over whether the artist is spoofing or *serious.*

In all of these examples, a kind of triangle of meaning occurs between the artist, the image, and the viewer. A male painter who paints a female nude is part of a long tradition where silent, naked female models are sites for the privileged gaze of first the male painter and then the spectator-owner. Indeed, such paintings were sometimes commissioned to depict the mistress of a powerful man in the guise of a goddess or heroine at the center of a mythological narrative. The image was thus *clothed* as a conventionally acceptable *nude*. That women are usually naked and men generally clothed in artworks was seen, until recently, as a *meaning-free* fact of tradition. As artists have begun to explore questions of where meaning occurs in works of art, questions about the nude have become inevitable.

How might the critique discussion change if we substitute male nudes in the above examples? When a male artist or female artist paints a naked man? How might we talk about these works if they have all been painted by women? Or men? In all four cases, the artists seem to be consciously *engaged* with the image of women through the depiction of the *female nude*. How might the discussion go if the student, who has created one of these works, vehemently denies any interest or awareness of this issue? Do the meanings that the viewer sees become part of the work? And if so, does it in any way become the artist's responsibility to acknowledge that?

Gender to Culture

Let's open up another can of worms. Now consider how the critique discussion might change if one of the works described above is a nude female wearing an African mask. Would you associate the painting with Picasso's 1907 modern masterpiece *Demoiselles d'Avignon*? Would you want to know if the artist had some particular interest in African culture? With Picasso? Would it change your view of the work if the artist happened to be African American? African? Owned the mask?

A high regard for non-Western and ancient art informed formalist criticism. Indeed, works from the continent of Africa, regions in the South Seas, and from Native American collections all had a major influence on the development of European modernism. It was thought that any work of art, whatever its cultural or historical particulars, can be directly apprehended through its form, because matters of form are universal. Critics have since argued this point. To a greater or lesser extent, the historical and cultural origins of any work are part of the equation of meaning.

The Postcolonial World

Let's move from *gender* to ask how *culture* operates in relation to authorship. We must first recognize that the dialogue around a work of art does not happen in a vacuum, but within a given cultural and historical context. That is, it changes in relation to the world around it.

If you were to travel back in time to 1950 and land in a critique at most any art school, you probably wouldn't hear people discussing anything found in this chapter. The nude would be taken for granted, most of the students and faculty would be well-dressed males of European heritage, and *Western* culture would just be culture. The

model would typically be female. Discussion would not address the cultural perspective of the artist, and there would be little writing about these issues, which are now part of the mainstream debate. This was not because the cultural origin of the artist was overlooked, but because the work was simply assumed to have been created from a Western European perspective. Any non-Western cultural imagery would still be contextualized within the Western tradition, usually as exotic, noble, primitive, or naïve.

The rise of feminism in the late 1960s and early 1970s, and the subsequent (and substantive) addition of women's perspectives to the mainstream of art making, forced artists and critics to consider issues of authorship. When we looked at the female nude earlier, much of our discussion was predicated on these ideas.

In the same spirit, we can look at how the addition of what we might call "non-Western" artists to this mainstream dialogue has changed the kind of work that is produced and forced us to consider the *who* behind any artwork. The addition of work produced from regions outside of the art centers in Europe and the United States, or by artists with cultural heritages or experiences from those regions, has changed the nature of the debate in significant ways.

The reasons behind this shift are many: the expansion of mass communication by way of the Internet, the emergence of a new trans-global art community, the increased influence of new nations, many still in formation out of a world once divided up into colonial spheres of influence. We are describing the *postcolonial world*. As was the case with the addition of significant numbers of women artists in the 1970s, the emergence of non-European artists in a growing global conversation both deepens and broadens the discourse for there are more stories being told by previously silent voices.

Affiliations

Let's consider works that reference a *culture* other than the artist's own. What if the artist who references another culture does it in the spirit of solidarity? Do the artist's good intentions override any unintentional misrepresentations? How do we define someone as being *other* than ourselves? How do we read a work made by a European woman that depicts an African and Asian woman standing together? Is she objectifying them from a position of dominance? Or does the artist's gender turn the *they* into a *we*? How do we define race in an increasingly intermingled world,

where labels become less and less definitive? These discussions become increasingly complex within the context of shifting social affinities, as the markers left by colonialism give way to other identifiers.

For many students, these concerns may seem to strangle creativity and threaten artistic freedom. Yet the complexities of the *who*, the *what*, the *when*, the *where*, and the *how* are all paths that lead to understanding a work in the fullest sense.

Content and Form in Political Art

Art made within the context of political change or work that seeks to catalyze such changes is often born out of urgency and necessity. Many artists working within these social dynamics assert that such circumstances demand an art that offers *readable* narratives—paintings, drawings, or sculptures grounded in realism, which is more suitable for conveying unambiguous messages that anyone can understand. From this viewpoint, both formalist abstraction and pretty landscapes are as objectionable as works asserting an opposing political view.

The play between form and content seen historically in the works of artists concerned with the social function of art is a complex debate. For those who stress the importance of readability, formats are favored that offer maximum narrative delivery. Work that is experimental, thus less readable, falls short. According to this way of thinking, the work might be inventive, it might be interesting, but in the end it does not communicate. Other artists who are engaged with social issues embrace a different way of thinking. They claim that new art forms, which challenge both social and *artistic* traditions, offer the greatest potential for dialogue in a changing world. Indeed, they argue that experimental language can expose the hidden power relationships that contribute to oppression. The question becomes whether it is possible to have revolutionary ideas in the tired old language of the socioeconomic structure that you are challenging. Do new ideas and perspectives require a brand new experimental delivery system? And, if so, will the message still be readable?

In 1986, the antiapartheid activist Albie Sacs declared (with tongue in cheek),

> . . . our members should be banned from saying that culture is a weapon of struggle. . . . Can it be . . . that when the comrades go to bed they discuss the role of the white working class? . . . What are we fighting for but for the right to express

our humanity in all its forms, including our sense of fun and capacity for love and tenderness and our appreciation of the beauty of the world? [and] . . . Let us write better poems and make better films and compose better music.[4]

Can images and forms become stale? Does the content of the messages make the delivery systems less relevant? Are accessible works more appropriate for communication to wider audiences or do we insult and patronize these audiences by entertaining such notions? What *is* the message? Whatever the message, do we still need to make better paintings, better sculptures, better films? What forms will these *better* works take? What images will they carry? Must form and image be constantly reinvented?

Aesthetic Horror
Subject matter and formal delivery can be intentionally contradictory. Francisco Goya's painting of Saturn eating his children is masterfully painted with fine luminous color. Yet it depicts a gruesome decapitated body of a child being devoured. There have been many gorgeous depictions of bloody heads on plates, tortures, and rapes throughout the history of painting and sculpture.

What about a beautiful and heroic portrait of a man guilty of hideous deeds? Is the artist complicit in the validation of such an individual? Or, conversely, might the artist be effectively addressing the seductiveness of power by catching the viewer in an act of admiration against his will? Is there a way to depict terrible things simply as they are, without judgment?

Immediate Readings: Putting Denotation to Work
In looking at meaning in critique, consider what might be an initial entry point. In some works, particularly those that operate with clearly readable narratives, we can enter the work by looking at *the story it tells*. Immediate readings are *denotative* and take us first to a straightforward description of what we see—a nativity scene, two soldiers wrestling, a city on fire.

Initial descriptions should be as specific as possible. For example, what if we describe the nativity scene as being a copy of a masterwork in which everyone is dressed in contemporary clothing? What if our description of two soldiers wrestling includes the observation that one is dressed in pink and one in blue? What if we see a painting with images of a city on fire, but the city is unrecognizable? What if the city

can be clearly read as New York? London? Baghdad? These straight-forward descriptions of *what we see* have already begun to address *meaning* in the work being critiqued.

Foregrounding and Meaning

The starting place for accessing a work's meaning is often an element that has been explicitly emphasized by the artist. This may take the form of compelling imagery, but it may also be a formal element that stands out, such as a color, shape, material, or an object's placement in a room. It may be that the work occurs on an unusual site or in an unexpected context. When an element has been pushed to the front of a work of art—that is, it stands in relief to the rest of the work—we say that it has been *foregrounded*.[5] In our quest for meaning, we can begin with our initial impressions of these foregrounded elements, and then proceed to peel back the layers.

Sometimes this peeling back occurs on site with careful looking, and other times through progressively deeper and deeper investigations into the things outside of a work that have informed it.

Imagine a video work. The piece is a short three-minute film that shows two figures wrestling. The figures are dressed in business suits. An initial reaction from many of the students in the critique group will be the simple observation that the video shows two businessmen fighting. In this scenario, the artist has *foregrounded* the business attire and the wrestling. We read the video as an allegorical statement about competitive capitalism. But, let's say that some members of the class recognize that these are not just generic executives, but the faces of real CEOs that have been keyed in by the video artist. What's more, the CEOs are from corporations that have been embroiled in a recent scandal. By foregrounding the identities of the wrestlers, the artist has now made the narrative specific.

Now imagine that the critique space has been set up to resemble a corporate boardroom and we, as viewers, are all sitting in chairs that have been arranged around a huge boardroomlike table and are turned toward a projected image of the wrestling video. The artist has now placed us in the scene, prompting us to ask about our own complicity in the scenario. Does the meaning change if we are told that this very video projection was smuggled into a real corporate boardroom the week before and presented, unbeknown to the officers of the scandalized company, in the place of a planned marketing video.

How important to the reading of the work is the recognition that the faces are from current media sources, and how important is it that we know the

story of the scandal? What if sounds of cheers and whoops are added to evoke a sports bar environment? What if the sound track plays a love song? What if we hear exaggerated groans and grunts, borrowed from a martial arts movie? In tracking the meaning of the work, we move from a simple description of a film of two men fighting to two particular individuals fighting on a video screen in a highly charged location.

Form as Content

We have seen how meaning can be explored through a peeling back of layers of imagery. But let us for a moment step back and consider works where there is no recognizable imagery. What if our immediate entry point is color? Sound? Scale?

What do we make of a three-dimensional form that seems remarkably small in relation to the room it's in? How do we read a print that depicts a tiny dense scribble that seems to float in an enormous field or one that shows a torso radically cropped and crowded against the edge of the picture plane? Here *scale* is foregrounded. Consider a work made with small objects arranged in a grid pattern on a floor, or a work made with those same small objects scattered across the floor. When we walk into the room, we would likely think *grid* or *scatter* before considering any individual object. Here composition is foregrounded. And with the scatter piece, the foregrounded composition leads to thoughts about gesture. We immediately wonder whether the artist carefully placed or just scattered the objects.

Lets look at those works where meaning resides wholly or at least primarily in materiality, design, composition, or another formal property. As we discussed in the chapter on formal matters, these works are often self-referential, works that are *about* color, form, materiality, space, or light. Meaning arises not through a reference to something outside of the work, but through the formal operations that occur within the work. In such works, we might even say that form *is* content.

Color

As we discussed in the last chapter, color is not always just a formal element but also can operate *as* content. Examples of this are works constructed entirely out of single colors of dried pigments, poured paint, or groupings of fragments from like-colored found objects; works where canvas and frame support a flat single color field that does not operate to the service of any image or pattern; or video projections of shimmering,

shifting color. When faced with these kinds of works in critique we find ourselves hard-pressed to say that the work is *about* anything beyond red, blue, green, or black, or whatever other shades or hues that the material delivers. A stretcher bar and canvas may support the color in a painting. Armatures or boxes may be employed to present or contain the pigments in a sculpture. A video projector may be used to produce a room of colors that swell and fade. But as long as those supports, armatures, or containers retain a low profile in the visual language of the work, color dominates meaning. In these examples, looking for narrative content doesn't lead us far beyond a simple naming of the color, and to a lesser degree, the shape and texture of the particular form that delivers it. Would we not say that these works are *just* about the color?

Color as Emotion

Nevertheless, color works on our emotions. Studies have documented the calming effects of blue, which some research has attributed to our ancient ancestors walking the flat African savanna under great blue skies. Blue can also signify depression, as in the American blues or Picasso's blue period. A popular belief among bullfighters held that a bull becomes dangerous when a red cape is waved in front of it.[6] Could this be related to the expression, "He was so angry he was seeing red?" A room bathed in pink light will have a different emotional impact than one bathed in yellow. Thus, even a six-foot-square blue canvas that claims to be only about itself can't help but work on our emotions as well as create associations if, say for example, the particular blue just happens to resemble the blue of a television screen as opposed to a big savanna sky. Whether our responses are hardwired or culturally conditioned, color can't help but carry with it some measure of emotional content.

Color as Symbol

Beyond its emotional charge, color can stand for things outside of itself. Whole books have been written about the various symbolic values of color, be they universally shared or culturally distinct. Green is jealousy, black is evil, yellow is cowardice, and so on. In many Western cultures, people get married in white and grieve in black. In India, weddings are brightly colored and death is white. For Americans, the combination of red, white, and blue is patriotism. During the Cold War, red was communism. In Imperial China, yellow was reserved for the Emperor,

and thus a forbidden color. Color operates in relation to the meanings that a particular culture has given it, sometimes directly standing in for an idea—as in red, white, and blue streamers at a Fourth of July party.

How does the image of a red and black Nazi flag change when we substitute the colors for pink and white? What happens if the red, white, and blue colors of the American flag are changed to shades of green? Does a subtle selection of one hue lead us to think of money and another, ecological issues?

Color as Index

What about more complex signifying functions with color, where color is arbitrarily assigned a meaning, as in a color key on a map, which points to various topographies, or the blue and red states that mark Democratic and Republican election results on television news broadcast. Here again, color becomes content, not by pointing to itself, but by being *indexed* to something outside of itself.

Let's consider a painting project by the artist Byron Kim called *Synecdoche*, composed of panels painted in colors that closely matched the skin tones of people who posed for the artist. Although these panels look like formal color studies, color has another meaning. The subtle tones of beige and brown are *indexed* to the color of each person's skin. The work at once references abstract painting and issues of race and identity.

Crayola

In critique we are looking at what appears to be a small painting of stripes. The arrangement of the colors suggests a spectrum, and we might first find meaning in the work by calling it a rainbow. Because it is an intimate work measuring less than 6" × 6" we might decide that scale is foregrounded and first talk about that. Displayed on the wall at eye level with no visible support or frame, it looks like a small abstract painting with a pattern of regular vertical stripes in colors organized to resemble a rainbow—the shades moving from violet to blue, green, yellow, orange, and red.

With a closer look, observant critique participants see that the painting is an inch thick, and that the striped pattern continues beyond the picture plane and around its edges. Further inspections reveal that the color is, in fact, not a surface application but a solid block! In other words, the color is not just a skin on a support but the material out of which the painting, now defined as an object, has been made. There is a saturated quality to the color, and many

students guess that it is pigment suspended in wax. Then one student notices that the work has a peculiar but familiar smell. At the same time a title card is spotted pinned nearby. It reads: "Crayola." The painting has been made with crayons that have been melted, poured into tiny U-channel molds, and then presented on the wall.

Here we have moved from abstract to rainbow-striped painting, to striped object to a box of Crayola crayons. Does it make a difference if these are the artist's own crayons or if the project has been done with found crayons? What if this is really just wax and pigment, and the title is a fake? How important is the smell? How important is the title card to a reading of the work? How important is it that the painting is really a solid object? And what if, when we take a closer look, we discover that this is actually a skillfully painted trompe l'oeil oil on canvas?

Thus color can be employed to evoke or *represent* meaning as well as *be* its own meaning. Works may be constructed completely out of color—whether made out of raw pigment, colored lights, or objects of a chosen color. Color can be completely self-referential, that is, *about* blueness, redness, yellowness, and the like. Saturated pigments can be applied to shapes that then read as solid blocks of color. Layers of paint can be applied onto simple three-dimensional shapes or two-dimensional supports that function as sites upon which the color has accumulated. Works can be created with projected, reflected, or framed light. Natural red oxides can be used to temporarily dye small pools in wilderness settings. Found discarded objects can be collected and arranged in groups of like color and configured into simple shapes. Plastic bags or clear vessels can be filled with colored water and hung in various configurations. Colored threads can be unwound into delicate airy piles. Video monitors can be stacked in a darkened room and left on glowing blue screen. All of these variables can create and modify meaning.

Patterns as Meaning

Patterns operate much the same way that color does to evoke meaning by referencing commonly accepted symbols or familiar cultural iconography. For example, a simple pedestal or a stretched canvas will read differently if uniformly covered in camouflage material, red-checked cloth, or tie-dyed fabric. One creates an immediate reference to the military, another to cartoon picnic, and another to hippie culture.

Palette

The kind of palette an artist uses creates its own responses in the viewer. A quiet, subdued palette and a loud, highly saturated one will solicit different emotional responses. Palette also contextualizes a work in relation to works by other artists or whole periods of art history. What happens when a painting of a '57 Chevy parked at an Exxon station is made of the nuanced earth colors of a Leonardo? Or, inversely, a Madonna and Child, rendered in the style of Filippino Lippi, is painted in day-glow colors. In each case the palette becomes *foregrounded* because it is unexpected. Likewise, within a work, if a relatively uniform palette occurs throughout, a sudden rupture of that system is foregrounded, as in a patch of bubblegum pink in a painting otherwise made up of umbers and siennas. Any painting restricted to only black and white is immediately noticed for its refusal of color.

A refusal of color becomes foregrounded when an artist is working within a tradition or medium that normally relies on color. A famous foregrounding of black and white in a color film are the scenes of dreary gray Kansas in the context of colorful Oz. Inversely, in the bleak world of Spielberg's *Schindler's List*, shot entirely in black and white, there is a single shot of a little girl walking on a gray urban street. The red of her dress is the only piece of color in the three-plus-hour film about the Holocaust, and appears as a small ray of hope in a relentlessly brutal and depressing film experience. Some magazine and television ads have recently begun to appear in black and white so that they are foregrounded against the color programming around them.

A Theater of Forms (Placement as Signification)

A single mark can *activate* a blank sheet of paper. A single object can activate a room. The dynamics of placement are critical to signification in works of art. This occurs when we consider the room (or site) around a sculpture to be a kind of active stage. In other words, we look not only at how our reading of the sculpture is informed by the object itself, but also by its relationship to the space around it. Let's consider how position and context can add yet another layer of meaning by going back to our axe on wheels monument. We might ask ourselves: How does the meaning of the sculpture change if it is placed at the center of a small room with a dramatic spotlight? How does its meaning shift if it is set up in a large room, jammed into a corner, and perhaps even facing that corner? How does its meaning change if it is taken outside of the crit room and set up in relationship to a real monument?

Whether a work is hiding in a corner, bursting through a wall, clutching a ceiling, basking in the spotlight, or even impersonating something other than itself, placement contributes to meaning through what we can call its *theatrical function*. In some ways, the sculpture behaves like an actor on a stage. This can be most easily recognized in a sculpture with strong figurative references. Meaning can be read not only through the modeling, gesture, or expression of the figure but also in relation to its location in the room. The artist acts as a kind of director in a staged drama. Even the most reductive abstract form can operate theatrically by means of its placement in space. A black steel box can be placed in the center or corner of a large room, attached high on a wall, left on an elevator or busy sidewalk. Each placement provokes a very different reading.

Configurations

The potential for placement is further expanded when the sculpture is made up of parts in various groupings. This allows for configurations that suggest tensions and affinities, affiliations and interactions. How do we read a single figure on a pedestal in contrast to a pair of figures placed nose to nose? What if they are back to back or huddled in a corner? Imagine fifty child-size figurative sculptures arranged in military rows or scattered throughout three adjacent rooms in loose gatherings. What happens when we put these same figures beneath the stairs of a fire escape or seat them in each of the four corners of a room? Imagine them placed with feet flat against a gallery ceiling or even walking up the wall.

Whether grouped in a circle or marching out the door, the configuration of objects in a space is the configuration of meaning. Does this theater occur within a strictly inscribed area? Are we, as viewers, positioned in this theater as audience, or do we enter the theatrical space as participants? Are the boundaries of this theatrical space at all negotiable? What is the relationship of this theatrical space to the world beyond the critique room?

Composition as Meaning in Paintings and Drawings

We noted earlier that a picture plane and a gallery space can each act as a context for an infinite number of arrangements of formal elements, that is, compositions. The way that forms or marks are arranged can, in

turn, point to meanings. A lone mark in a large field of white can express lonely isolation, a large form crowding out a smaller one can seem to be about power and overthrowal. A densely cross-hatched picture plane can feel heavy and depressed. Like-sized forms, symmetrically arranged, can say order, whereas haphazardly scattered organic shapes of various sizes invoke chaos.

Let's go back to our image of businessmen and sit them around a boardroom table. This time we have a fairly realistically rendered oil on canvas. What can we read into the image if the table runs horizontally across the canvas and the figures are evenly spaced along the horizontal axis, as in Leonardo's *Last Supper*? What if all of the figures are wearing gray suits with black neckties? Does each figure read as one among many equals? What if all of the figures are faceless? We are beginning to read a content into the work that has to do with replaceable corporate drones, a loss of humanity, conformity, and so on. What if the central figure has his hand out in a gesture or is wearing a bright red necktie? Does he suddenly become the focal point of the narrative? What happens if the table is round and the closest figures have their backs to the viewer? Or the long table is turned 90 degrees, and rendered in one-point perspective so that one figure sits at the central vanishing point, facing the other figures at the table, who look back at him? In this scenario, the spectator seems to stand behind the seated figures, participating in and reinforcing the formation, which empowers the central figure. There are endless arrangements and formal choices that can point a narrative in one direction or another. Much of this comes to light when, at the start of a critique, we simply describe in detail what is in front of us.

Format Choices as Meaning in Paintings and Drawings

Is there such a thing as a neutral or ideal picture plane, that is, a picture plane that isn't associated with anything outside of itself? What shape would it be? A rectangle placed horizontally suggests a landscape; placed vertically, a portrait. An extreme horizontally placed rectangle can reinforce a feeling of claustrophobia if the image it carries is a man lying in a coffin underground. It can make a panoramic landscape more panoramic. Even so, artists have consistently accepted conventional rectangular formats as relatively neutral, conceding that any implicit meanings have been all but extricated by the pervasiveness of such paintings within the tradition.

Nevertheless, this is one reason many abstractionists have embraced the square, a rotatable shape that is thought to elude associations with the outside world, and that lends itself to grid-based constructions. With no top or bottom, the perfect square appears to be the most self-referential format, rejecting systems of perspectival and narrative space in favor of flat nonhierarchical visual systems. Indeed, a square field painting may actually *signify* a refusal of narrative.[7]

The Inevitability of Meaning

Let's look at how signification can still operate in the most reductive abstract work. Take four identical square black acrylic paintings:

Four Black Squares

The first square is called *Study #1*. This black square might be read as a self-referential formal investigation.

The second black square is called *Window into a Void*. This might suggest that the artist is using reductive painting to explore optical illusion, the black square reading as a deep space beyond the frame.

The third black square is titled *Representing the Un-Representable*. Perhaps we'd read this one as symbolic of a spiritual exploration.

Finally, the fourth painting is titled with a simple date and a name. We learn that it is a memorial to a friend of the artist.

In the first black square, form is content. The black square is *about* the materiality and blackness of black pigment and the symmetry of a square support. Period. The second work creates an optical effect and addresses painting's traditional role as an imaginary window frame, creating a momentary illusion of a space beyond the space of the room. The smooth handling of black pigment to produce the most convincing illusion of a hole in the wall becomes crucial here. The notion of a black square operating as symbol is explored in both the third and fourth works. In the third, the abstract form is not self-referential but refers to a transcendent idea that the artist claims to be unnamable and unrepresentable. The fourth piece relies on shared associations with the tradition of black mourning veils or armbands. In other contexts, associations with South Africa's black sash antiapartheid protest group or the Islamic black chador, for example, could come into this symbolic reading. Consider how the fourth black painting would change in meaning if we

were to find out that our square painting is not a painting after all, but a black cloth stretched over a frame and presented like a painting. And what if this cloth is actually a fragment of the memorialized person's clothing and is itself charged with symbolic value?

Let's continue our example to make one more point, by imagining that another artist comes in with a fifth black square painting, just like the others, and sets up a small title card that reads: *Five Surrogates*. His work now pulls all of the other black paintings into the context of a series of multiples and all that this implies in terms of mass production and questions of originality.

Gesture as Meaning

A figurative work communicates a wealth of meaning through the gestures of its figures. Is the head bowed in defeat or reverence, are the arms raised in victory or lamentation? Does the figure seem to stride or scurry, slink or strut? Does the turn of the head seem effortlessly graceful or strained and distorted?

Do these same principles apply to a nonfigurative work? An abstract sculpture made of steel rods might curve and flow through a room in such a way that our eyes follow the lines around the space. The rods might form a dense knot or explode outward in all directions. They might collide with the wall and bend against it or form a complex grid that blocks our path. A single rod might be placed floor to ceiling or laid on the floor. Each of these configurations has its own gesture—it explodes out, turns in on itself, aggressively attacks, or blocks our path. And although these configurations are formal, they attack, intrude, and so on. Indeed, form carries with it an emotional content. An abstract form can suggest figurative gesture. Gesture can also be explored in abstract work through movement of the viewer's body or eye.

Gesture is also present in work when the act of its making, that is, the artist's gesture—remains evident in the form. When material *and* process of construction are foregrounded, then the *meaning* of a work will be described in terms of the actions that have created the work—for example, scattering, tossing, pouring, or tying.

Gesture works the same way in a drawing or painting except, once again, our context is a two-dimensional picture plane. A drawing's surface reveals that it has been scribbled, scratched, or erased. A painting that has been poured or flung into existence becomes the

evidence of this pouring or flinging. Drips and drops, lines and marks of paint on a surface contain a discernable energy and direction of movement. When we see a painting that consists of drips that start at the top of the canvas and drip down and eventually off the canvas, we think of paint or solvent being poured and a collaboration between the artist and gravity. Works like these that are records of an artist's activity foreground the act of painting, such that the marks or drips of paint become signifiers of the act. How do you read a painting whose surface is covered with what seem to be quick, multidirectional brush strokes, as if the artist just whipped it out all in one sitting? Do the marks become signifiers of the spontaneous act itself? At the same time doesn't our eye follow the marks as they point in one direction after another? A heavy brush mark of paint that diagonally slices across the canvas creates a directional, unstable dynamic movement that can support or undermine a narrative, or simply mark off space. A uniform series of six four-inch-wide vertical strokes that move horizontally across a canvas will create a horizontal rhythm or anchor a group of curved lines of paint beneath them. Note also that a rectangular canvas has an upward or sideways gesture depending on whether it's presented vertically or horizontally. The neutrality of a square is, in part, because of the static nature of its gesture.

Material as Meaning

What a work is made of contributes to its meaning. If an artist carves a hammer, figure, or a fist out of wood, leaving the wood grain visible, then the carved image will be inseparable from associations we bring to wood. The rough, chiseled surface becomes evidence of the act of carving. And the material itself will carry associations of other things made of wood, such as crafts, instruments, or tools.

If a sculpture is made with perfectly fitted joints and expensive woods, craft is foregrounded. In fact, we might even conclude that the meaning of the work is as much about *woodworking* as it is about hammer, figure, or fist.

Our lived experiences with a given material come into play when we look critically at how material choices influence meaning. Imagine a large pot turned on its side. Made with hammered steel, it can be read as a fragment of armor—referencing something from medieval or modern warfare. The same vessel, made out of sun-baked clay, might make us think of primitive architecture.

Noeth

In the fall semester of 2001, a student brought in for critique what appeared to be a small ink drawing on a piece of primed canvas. It was an image of a sailor and was titled *Noeth*. He said it was a drawing of a friend of his. The *meaning* (or *content*) of the work at first seemed pretty straightforward. We initially discussed it in terms of scale. Why, for instance, did he make it so small? The size clearly lent itself to an intimate reading by the viewer. And what about the support? Why did he put it on a piece of canvas rather than on paper (especially as the canvas wasn't even stretched onto a support)? Why did he leave the plain white gesso ground unworked? Although it was nicely rendered, the work didn't have much impact. The student then told us that this wasn't ink on canvas but blood. Indeed, he had painted the image with his own blood. Suddenly the meaning changed. The intimate scale was now tied to the intimate act of cutting through skin to take one's own blood and the intimate feelings that must have prompted such an act. The piece began to take on a very different narrative meaning that issued from what the image was made of. The student went on to say that this was, in fact, a portrait of a friend of his that had recently been killed when, on September 11, a plane flew into the Pentagon. Our reading of the piece was radically transformed again. The object in front of us was now an act of mourning, a tribute, a political statement, a response to incomprehensible loss. Indeed, the little drawing, which hadn't physically changed at all since our first look, was radically transformed.

One Man's Ceiling Is Another Man's Floor

Clearly, materials are not neutral. They contain meanings, which can be deployed by an artist to support, contradict, or run parallel to a narrative. Indeed, they can control narrative meaning. Chris Ofili's painting of the Virgin Mary was derided by critics and officials, offended by the fact that one of the materials that he used in the work was elephant dung. Like Andres Serrano's *Piss Christ*, Ofili's *Virgin* became a lightning rod for the forces for and against First Amendment protection of contemporary art practices.

In part, as a result of the controversy, material *became* the narrative content of the painting. For his critics, the dung represented an insult to the subject, the Virgin Mary. However, Ofili, a British artist of Nigerian descent, who began incorporating elephant dung into his work after a trip to Zimbabwe, said that this was a way of literally incorporating Africa into his work. In fact, the artist credited by name the elephants from British zoos that donated their *material*. His *personal narrative* was

a counterpoint to that of his critics. "There's something incredibly simple but incredibly basic about it," Ofili said. "It attracts a multiple of meanings and interpretations."[8]

Material and Process as Meaning

The British sculptor Antony Gormley's *Field for the British Isles,* at the British Museum, was an installation created with approximately forty thousand small terra cotta figures arranged in a tightly packed configuration to cover an entire gallery floor. As with his other *Field* projects, the installation was the result of a collective effort with local communities that shaped the simple figures.

Clay was the only material used in the sculpture, a material with ideal physical properties for simple modeling and for the kind of collective production used to shape the thousands of individual pieces that made up the installation. It is a material most closely associated with the small figurative artifacts of our own ancient history.

The Medium and the Message

If you were to write a description for a doctor of what you ate yesterday, it would probably be a relatively straightforward account in plain language, since your primary goal would be to give the doctor the information she asked for. The language that you chose would be pretty *transparent*; that is, it would make itself invisible to enable you to *communicate* your meaning. It would simply be a vehicle for your message. But let's say you wanted to write a *poem* about food, you would likely choose your words carefully and arrange them to create a structure that did more than just *communicate* meanings. You might want the words to rhyme at the end of each line, for instance. You would probably choose words that were rhythmic and arrange them to follow some kind of metric structure. Perhaps you would try to create connections between what a word *signified* (its meaning) and what it sounded or looked like. The more poetic your language became, the less *transparent* your narrative meaning.

The poetic language you created would take on a life of its own, stand away from a clear narrative, and become more separated from single dictionary meanings. It would take on other meanings through associations created by its structural relation to the other words in your poem.

This example can help you think about the idea of *transparency* in general. For the doctor, you used language as an invisible carrier of meaning. In the poem, you created a more complex language that carried multiple meanings. This poetic language is more *opaque* than the *transparent* language you used with the doctor. Opaque language *covers over* narrative meaning by pointing to itself, while at the same time expanding the possible meanings by the associations it creates. Imagine running water in a creek coming up against a rock and spreading out in many directions.

Although visual language, at its most transparent, can be used to sell products or change someone's political views, our concern is with the *poetic function*. And though historically paintings were often used to convey religious narratives to people who couldn't read (a *communicative* function, which is also *didactic*[9]), the best painters managed to mix the communicative function with the poetic, that is, to *move* viewers by giving them a complex experience, while they also gave them information. Art is at its best when it can be *experienced* on several levels rather than just "gotten," like the punch line of a joke. The *experience* of a complex work of art involves the perception of a complex structure of some kind, rather than an instantaneous *reading*.

In that vein, the novelist Mario Vargas Llosa, addressing an audience at the Folger Theatre[10] in Washington, D.C., made this distinction, "For a journalist," Vargas Llosa explained, "language is an instrument. For a writer, language is an instrument but it is also a goal." This is as true for the artist as it is for the writer.

The Meanings of Transparency and Opacity in Painting

When we speak about transparency in language, we really mean using words in the clearest manner so as not to obscure or overly complicate the message or narrative we are trying to get across. Transparency in painting is a bit different. It refers to the viewer being able to make the actual paint and the surface of the canvas invisible in order to transform it into an illusion. But as with transparent language, this illusion is the carrier of narrative content. To illustrate this, let's imagine two paintings that contain the image of a woman—one is a painting by Vermeer, the other is one of de Kooning's *Woman* paintings.

The painting by Vermeer is more transparent than the de Kooning. For when we look at the Vermeer, there is nothing on the surface that

catches our eye. We look straight through, as if looking through a window, into a three-dimensional space. We don't see any evidence of the artist's hand. It's as if by magic this painting appeared before us, complete and without any traces of its making. The Vermeer completely hides the materials and actions that were deployed on the painting's surface, so that the viewer's eye doesn't linger there.

The de Kooning does something very different. It *foregrounds* the paint and the artist's gestures at the surface of the canvas and stops the viewer's eye from entering into an illusion. The painting is flat! The window has disappeared. What is happening on the surface of the de Kooning is an integral part of the image and, thus, how we *read* it. It marks the place of meaning. Indeed, the image of the woman in the de Kooning is constructed a jungle of competing physical brush strokes that appear almost to be attacking the very image they are forming. Meaning resides on the surface, where thick brush strokes embody evidence both of an authentic and expressive act of painting and of an attack on the image itself. The viewer might wonder whether the artist is attacking women, conventional narrative painting, or is just having a bad day.

In the case of the Vermeer, the transparent *language* that renders the surface all but invisible gives way completely to the image, so that the image becomes a clear container for a narrative content. We look through the window into the room to construct a meaning from the relationships we see within. In the de Kooning, the surface has barred us from entering an illusionary space. The image, almost invisible, has given way to the surface. The Vermeer is a *transparent* painting, the de Kooning an *opaque* one.

For both painters, language was both instrument and goal. De Kooning's language points away from illusion and toward itself. It exalts in its own expressivity, in the act of its becoming. For Vermeer, language has been perfected in such a way as to vanish from sight, leaving an image so seamless, it might have just fallen from the sky. That isn't to say one is more poetic or artistic than the other, as in the journalist and the poet. For in the visual arts, where meaning is also embodied in a work's materiality, where language itself is material, transparency must be skillfully deployed for the sake of narrative content. And for this kind of painting, the complex meanings are found in the many formal imagistic devices, such as composition, color, line quality, draftsmanship, and the operations of iconography.

Reading Transparent Paintings

The surface of a Vermeer is smooth and has many thin layers of glaze, which make it both reflective and deep. When we look at any painting by Vermeer, we are watching light travel through its many thin transparent layers until it reaches the bright white reflective ground beneath. Here the light makes an about-face and travels back through the same layers, back out of the painting, and to our eyes. Thus, the luminescence of such paintings. What can you infer about a painting whose surface is so invisible that it hides any trace of the hand that produced it? We see first off that the image seems to be more important than the artist or act that created it. It points the viewer's eye away from the surface, away from the artist's act, and toward the image itself.

Thus, we can start here, with the image itself. What kind of space is being created and what is depicted in it? In other words, what is actually *in* the picture? Is there an overall palette? Can we see brush strokes? What kind of a composition are we looking at? How stable is it? Can we see a pattern created by light or color that links figures to objects, or figures to other figures, objects to other objects? Does something dominate because it's centered, or larger, or painted with a color that stands out? What is the figure doing? Are there several figures? How are they arranged? This can go on indefinitely as meanings are discovered through careful looking.

In traditional painting, visual language is constructed out of pigment, painting mediums, the canvas support, along with the way those materials are organized in relation to a pictorial surface and physical support. The laws of physics in relation to the choice of materials—gravity, solubility, fat content of paint, refractive index between pigment and medium, transparency, permanence, and so on—form a resistance to the actions of the painter. The transparent illusionist painter overcomes and resists the presence of the materials for the sake of pure illusion.

Media and Meaning

But painting also can simply be material applied to a surface, and that surface can be just about anything that will receive the material! Here again the material in a sense becomes the narrative, whether cut paper shapes on canvas or collected sequins pinned directly to the wall, whether ink injected underneath someone's skin or spray paint on concrete.

It's the same with sculpture. Imagine a room filled to knee level with moist soil or hundreds of polished white stones placed very close together covering a cathedral floor. Or imagine a large rectangular shape on the floor made with yellow pigment, or the same rectangular shape made with sifted bee pollen, poured wax, thrown lead, coiled ropes, or pools of oil. All of these works *foreground* material at the expense of narrative image. At this juncture painting and sculpture begin to overlap. Is a flat red pool of liquid a kind of painting on the floor or a sculpture? What about pure blue light on an LED screen?

Low Profile and High Profile

Material actively participates in a work's message. Given the array of potential materials one can employ, the possibilities are limitless. A simple form constructed like a beach ball might be made with flexible steel sheet, paper strips, plastic sheeting, or shredded bamboo—all to very different effects. These are *low-profile* materials. They don't bring with them strong associations but operate primarily as raw material to be transformed. Examples of some other low-profile materials are straw, steel, wood, plaster, clay, and cement.

But what if we construct this ball out of materials like political posters, razor wire, medical tubing, Campbell's soup cans, or yarn that we have unraveled from all of our childhood sweaters? These are *high-profile* materials. High-profile materials, when used in constructed sculptures or collage, maintain much of their original identity.

A sculpture constructed out of standard two-by-fours is read differently from the same form made with pieces of recycled furniture. Consider the shift in meaning when a cameo is constructed out of a carved block of plaster as opposed to a carved aspirin. A portrait made with paint from tubes changes when it's painted with toothpaste. An architectural shelter constructed with lumber differs from one built out of stacked milk crates.

NOTES

1. Eagleton, Terry, *Literary Theory, An Introduction*, Minneapolis: University of Minnesota Press, 1989, pp. 113–114. For a clear, demystifying overview of some of the most influential theories on the visual arts, this book is mandatory reading.

2. Taylor, Joshua, *Learning to Look: A Handbook for the Visual Arts,* Chicago: University of Chicago Press, 1981, pp. 51–68.

3. Berger, John, *Ways of Seeing*, British Broadcasting Corporation and Penguin Books Ltd., London, 1972 (based on the BBC television series with John Berger).

4. Sachs, Albie, *Preparing Ourselves for Freedom, Spring Is Rebellious*, original paper prepared for an ANC in-house seminar on culture, ed. Ingrid de Kok and Karen Press, Buchu Books, Cape Town, 1990, pp. 19–28.

5. *Foregrounding,* originally coined by the Russian formalist Roman Jacobson for analyzing literary works by breaking them down into linguistic functions, also can be a useful term for talking about art. We use it to refer to that which stands out as unexpected in an aesthetic system, that is, an artist's general emphasis of one element over others. For instance, if a highly realistic painting of a landscape has a surface that is covered with energetic and thickly gestured brush strokes, the surface is being *foregrounded*. It is going against our expectations for transparent illusion and calling attention to itself. By noticing what is *foregrounded* in a work, especially at the beginning of critique, we can begin to discover the meanings embodied in its formal structuring.

6. It turns out that bulls are colorblind.

7. For an interesting discussion and critique of the idea that a neutral ground for painting is even possible, see Rosalind Krauss's article *The Originality of the Avant-Garde: A Postmodernist Repetition*, originally published in *October*, no. 18, Cambridge, Mass., Fall 1981.

8. Vogel, Carol, "Chris Ofili: British Artist Holds Fast to Inspiration," September 28, 1999, "Holding Fast to His Inspiration: An Artist Tries to Keep His Cool in the Face of Angry Criticism," Carol Vogel, *New York Times*, Section E, p. 1, September 28, 1999.

9. The term *didactic* comes from the Greek word *didosko* (*didoskein*), which means *to teach*. Thus, *didactic art* is art whose purpose is to teach—in this case, religious stories from the Bible.

10. Mario Vargas Llosa, a Peruvian novelist, playwright, essayist, journalist, literary critic, and statesman, held an open conversation and read from his work October 14, 2003, at the Folger Shakespeare Library in Washington, D.C.

Chapter Three

MAKING AND TAKING

AUTHENTICITY AND APPROPRIATION

The Question of Craft

Making art is work. Sculptors chisel, grind, polish, bind, dig, hammer, fasten, hang, move, lift, trowel, mix, sand, file, drag, hoist, weld, cut, measure, slather, sift, sew, weave, braise, model, press, saw, and drape. Painters brush, dab, scrape, drip, rub, knife, glaze, squeegee, pour, peel, stretch, sand, and dip. Film and video artists create sets, find locations, light, shoot, direct, edit, and sometimes even construct elaborate environments for presentations. Appropriately, we refer to our studio production as our *work*. The word *oeuvre*, which also means work, more accurately refers to the whole body of an artist's studio production, current and past. Individual *works* are seen within the context of an artist's *oeuvre*.

What are we then to make of work that does not involve the kind of *physical* efforts that we have just described? How do we critique work that lacks evidence of technical skill employed in its making? How are we to evaluate works of art that have not involved *any* kind of making? How do we define skill in such work? Can a work that is the product of weeks of back-breaking, disciplined effort be judged by the same standards as one that is the result of a five-minute Internet search? Or something manufactured in a shop by others? Is there a special virtue infused in a work that is labor-intensive, or is the time one puts into a work more than the clocked hours in the studio? Is the physical activity of making the only consideration, or is the artist's total experience of observing, thinking, and gathering also valid? Can a work be so conceptually engaging that any attempts to judge it in terms of the way it has been made, or even *who* made it, become irrelevant?

Authenticity

We might argue that things hold within themselves, and even communicate, the history of actions made on them. Objects that show signs of physical engagement, whether from the actions of an artist, or by nature—such as river stones that have been slowly polished by running water—have a special kind of beauty. Such objects seem to have a particular kind of *authenticity*. Their qualities are a direct result of what has happened to them over time. If an object comes into existence through discipline and labor, it earns value. It is a product of sustained and careful attention. The power of such objects is that they embody the uniqueness of an individual artist's hand.

Walter Benjamin, in his famous essay on art and mechanical reproduction,[1] describes value attached to artworks that have, on the one hand, to do with image or aesthetic qualities and, on the other, an object's *aura* or cult value. An object's *aura* comes from the idea that it is a container of memory, where it has been, who has touched it, what genius gave it its form. Its unique history gives it its aura of authenticity. This is, in part, a simple supply and demand equation that makes rare objects valuable, for example, Jackie Kennedy's wedding dress or a handkerchief dropped by one of the Beatles. But objects first identified by their remarkable image or *exhibition value*, such as the Mona Lisa, also can have a *cult value* (authenticity) because there is only one of them, because Leonardo touched their surface, because they have survived the trials of time. One-of-a-kind cult objects may have been *manufactured*, like a pair of Marilyn Monroe's high heels, *crafted* like a Stradivarius, or simply *experienced* like a flag that traveled on the space shuttle. The *aura* attached to these objects makes them rare and remarkable.

Reproductions seem only to have exhibition value. These may be beautiful stamps, well-designed political posters, or nature photographs. Such images can still acquire a measure of *cult value* when they become rare. These images—that are inherently copies—can take on the status of originals.

Thus, found objects, ready-mades, and appropriated images also bring with them a kind of history. Many carry rich associations of their original life in the world. New objects make reference to the mass production that is so much a part of our lives.

Appropriation

When an artist appropriates images, he may make a copy of an original, make a copy of a copy, or make a copy of a detail (or part) of a whole. He may alter an *original* page from a mass-produced comic book or work from an enlarged photocopy of it. He may tear out an image from a magazine, or project that image onto a canvas and paint it in. An artist might make a perfect copy of an Old Master's painting, signature and all, or sign his own name to it. In all these cases, he is taking (or appropriating) images. The appropriation of images can have very different and complex meanings, which are directly born out of the choices an artist makes about *making* and *taking*.

MATERIALS WITH IDENTITY

Review of High Profile and Low Profile

Let's review some concepts covered in the previous chapter. There we spoke about the *high-profile* and *low-profile* materials, defining *low profile* as raw material that carries with it very little image or reference to other things. *High-profile* materials were those that bring with them distinct images or strong associations from their original functions and identities in the world. For example, a sculpture constructed by tying standard lumberyard one-by-twos with rope can be contrasted with a like sculpture made out of pieces of lawn furniture and bungee cords. An oil painting of a landscape can be contrasted with a collage made of cutouts from a travel magazine.

On one end of the low-profile/high-profile continuum are the sculptures, paintings, and drawings made completely from raw or *low-profile* materials (plaster, clay, paint, and canvas, charcoal, and paper). The *stuff* this work is made of does not bring with it an already formed image from the world.

Next are works in which more high-profile materials are used but that still carry with them very little of their original identity. Examples would be magazine photographs cut up into small pieces and collaged to form a landscape, or found wood cut into random shapes and used to build a planar sculpture.

Moving along the continuum are collages or constructions in which the original sources are more evident and, indeed, critical to a reading of the work. In some of these works a material is used not just

for what it will *do* but also for what it *references*. The conceptual basis of the work is solely dependent on the choice of a high-profile material used in its construction. Examples might be thousands of tiny green toy soldiers glued together to create a ten-foot-tall flower, or a large orange colorfield painting made entirely out of packages of orange duck sauce carefully glued to the canvas.

High Profile Leaves the Service

Wherever we place a work along the continuum—whether high or low—the artist is still using the objects as material for the creation of another work, and there is still a considerable amount of good old-fashioned building, composing, cutting, and pasting. *Assemblage*—a broad term that refers to an artwork made from various objects—can be applied to what is described earlier.

But what about work that involves mostly taking and placing, and very little making? What about high-profile materials that are no longer at the service of a collage or construction but rather assert themselves as independent entities?

Change in Context (Readymades)

In 1921 Marcel Duchamp submitted a controversial work to the New York Armory Show. It was a urinal he had purchased and on which he had scribbled the signature "R Mutt." Duchamp refuted critics who later tried to assert that the work called attention to the beauty in common objects or that his choice of the urinal was aesthetically driven. This and other found objects, or *readymades,*[2] as he referred to them, were works of art simply because he called them so. An object becomes a *readymade* when it moves from one context to another, in this case, from the plumbing supply store to the art gallery.

The effects of Duchamp's action are still felt in critique rooms when the inevitable object with little or no alternation appears. Does something become art simply by someone declaring it to be so? If so, does its validity rest on the artistic credentials of that someone? Is the meaning of a work primarily located in the fact that a found object has been taken from a nonart context and placed into an art world context? If we take *anything* into the critique room (or gallery) and place it in the middle of the floor, will the meaning change simply by virtue of its new context? And, if this is the case, then how do we judge such a work in critique? How does craft enter into the discussion? Is *taking* as valid as *making*?

NOTES

1. Walter Benjamin, *Illuminations, 'The Work of Art in the Age of Mechanical Reproduction,'* ed. Hannan Arendt, trans. Harry Zohn. New York: Harcourt, Brace & World, 1968, pp. 217–251.

2. Cabanne, Pierre, *The Documents of 20th-Century Art, Dialogues with Marcel Duchamp,* trans. from the French by Ron Padgett, New York: Viking Press, 1971, p. 47.

Chapter Four

THE WORK IN THE WORLD

CONTEXT

In the last chapter, we looked at how objects in the world can become works of art when they are brought into a gallery, museum, or in our case, a critique room. In this chapter we will take a closer look at how *context* operates outside the critique room, and then consider those works whose meanings reside solely in their particular interaction with the world outside the studio, the museum, the gallery, the critique room.

Untitled

When public television correspondent Paul Solman[1] went to the Whitney Museum to shoot a news story about its 1997 Biennial Exhibition, his camera crew left some equipment, including some cables and camera cases in a pile by a wall. They went off to interview some of the artists, and several hours later when the crew returned, they learned that many of the museum-goers had mistaken the pile of equipment for a work in the exhibition. People had come up to it, looked it over carefully, and discussed its merits. A guard stationed nearby, after being asked several times what the piece was called, told them that it was "untitled."

The Context of Official Exhibition Spaces

Recontextualization occurs when a found object or appropriated image is brought from the world into the exhibition space. It can also occur when low art is brought into the high art arena. Velvet paintings by the side of the road or over your aunt's sofa may be kitsch, but exhibited in a prestigious gallery, they become *high art*. A painting hanging in a blue-chip New York gallery will be read differently from the same painting hung over the sofa in a middle-class living room,

sticking out of a dumpster in a rough neighborhood, or leaned up against a wall in an art department painting studio. In each instance, the viewer makes certain assumptions that inevitably inform his reading of it. A prestigious gallery setting creates an aura of legitimacy around a work.

Galleries create a context for works that may seem neutral but are anything but. A lot of space around the paintings on its walls sends the message that each painting is valuable and the viewer should spend time looking at it. A gallery exhibition that consists of many paintings hung salon style may give the opposite message: Like an open market, we have many works, and none of them is particularly special. Labels next to works with prices on them will signify that the gallery is really a store (which, of course, it is), and the works being shown are objects for sale. High-end galleries keep titles and prices on a list far away from the work, which lends the gallery the aura of a museum. The hidden message is that the work being shown deserves to be in a museum and is thus very valuable. It is, first, a work of art and, second, an object for sale. Any monetary transactions are done behind the scenes for an initiated few.

The Door

A blue chip New York gallery with massive foggy glass doors announces its street presence. The two big doors seem to be intentionally set up so that the visitor pulls when the door should be pushed or vice versa. The uninitiated inevitably bump against the door as they push and pull themselves into the quiet, cavernous, church-like gallery space. Posted just inside the door to the far left is the desk of the gallery assistant, who disdainfully watches the clumsy antics of entrants. If you know the door, you are an initiate.

Group exhibitions contextualize work. A wall construction made of found wood, straw, and colored tape will read very differently if it is in a curated group show called *New Strategies in Abstraction* than if it is in a juried exhibition of arts and crafts, or if it is included in an exhibition of wall reliefs, all made with natural materials.

Works Outside the Gallery

We are used to seeing public sculptures in parks and corporate plazas, murals on the sides of large buildings, and elaborate graffiti on

subway trains or walls in urban settings. We don't think about it much because public art, murals, and even graffiti all seem to belong to the spaces they occupy. The lines between mural painting and graffiti art can be blurred given that graffiti techniques and styles have become integrated into the language of murals. For some critics, combining the words graffiti with art is oxymoronic. For them, graffiti is vandalism when the canvas is private property or a public site that has been painted without official sanction. Both murals and graffiti can be taken off the street and placed in the gallery when, for example, artists are invited to produce temporary paintings on site or use graffiti techniques in paintings. It should be mentioned that, within some circles of graffiti art culture, if the work is no longer guerrilla it is no longer by definition graffiti.

What about a painting that is taken out of the gallery and put on the street or out into the community? Imagine a striped piece of cloth exhibited as a painting in a gallery. What if the same cloth is used to create a group of tents or placed in a location so that when passengers on a train speed by, the stripes flicker past the windows?

Site Specificity and Site Responsiveness

Some works are created in response to the particulars of a given site and others are so dependent on those sites that they do not exist at any other site. Some are architectural additions or alterations to a space, or works that are built on site. But others are works that derive meaning from their placement in a particular place in the world.

Some examples:
An artist makes tiny ceramic bricks that he then uses to construct small sculptures in the crevices of brick walls in alleys all over town.

A large photograph of a man hangs like a banner from a government building in a European city. The title of the work is *Passed by at 12:30 pm May 5, 1979 on this Street.* The work is installed on May 5, 1989.

An artist determines the exact center of a city through complex and exact mathematical methods. At that geographical point—a seemingly hidden and inconsequential spot behind a hedge—she places a red disc.

CONTEXT AND CRITIQUES

Actions Outside the Critique Room

Most of us have experienced performances by artists, which take place at a set time with an invited audience. In critique, however, we are sometimes asked to discuss actions that occur off site, or are realized in a time frame that makes it impossible to simply watch and discuss.

> Examples:
>
> After school each day a student goes on a two-hour walk, always taking a different direction.
>
> A student is silent for thirty days. She communicates only through notes on a small pad.
>
> A group of students, all dressed in suits, goes to a small diner in a nearby town. They discuss in audible tones an upcoming mission to Venus.
>
> A group of artists in a museum exhibition arranges to have all of the works removed to a warehouse. For twenty-four hours everyone, including the gallerist and the curator, think the works have been stolen.

Some are actions created for the *artist* to experience something alone—self-imposed silence, a walk without destination. In others, the artist engages the viewer in a manner that challenges typical social interaction. Although in many, the artist plays a subversive role, in that she does not announce herself as fiction. All, however, operate with a porous relationship to real life.

Critiquing Works That Must Be in the World

When the context in which a work is shown is central to how we read it, we come to the critique room with the recognition that the work is being looked at in a strange sort of laboratory. Therefore, in most critiques, though we are limited to what is in front of us, we may need to address how such works operate outside the critique space.

For some works, it's enough to speak about them in relation to the other contemporary works, historical precedents, or how they might be contextualized in a group exhibition. Here, substantive discussion does not depend on the work being taken literally or speculatively out of the neutral space of the critique room.

Other works, however, which can *only* exist outside of the critique room, present special challenges for the discussion. Critiquing certain sculptures or performances in public places, murals, guerrilla artworks, or private actions requires inventiveness and flexibility. How do we approach such work in critique?

The Off-Site Critique

If you make works that exist outside the critique room, you are responsible to get the group to your work, be it a simple stroll around the corner, a class trip on the bus, or a map with directions to the site, handed out the previous week. How the piece is read is directly linked to your presentation of it. If your piece takes the form of an event or action that has happened prior to the critique, documentation becomes an integral part, indeed, becomes a stand-in for the work, both in the critique room and later in the gallery. Thus, the thoughtful presentation of documentary evidence of an action or performance—be it text, photos, or video—is critical to any meaningful critique of it.

Pink Things

It is the first snowfall of the season. A student gives everyone in the class a map of the city with pink dots at various locations within a twenty-five-mile radius. Over the course of the week everyone is instructed to visit the seven sites. At each site is a different artwork. At one the student has skillfully wrapped an entire eight-foot tree in thin pink strips of fabric. In another he has sewn a transparent pink sleeve over a parking sign. Other works on the map include a pink cushion attached to a park bench, a pink curtain installed at the entrance to a men's room. Students are asked to travel to the sites and write about the work and their experiences.

NOTE

1. *NewsHour with Jim Lehrer*, MacNeil/Lehrer Productions, Paul Solmon, Correspondent, 1997.

SECTION TWO

Having the Discussion

Chapter Five

CRITIQUE DYNAMICS

GENERAL CRITIQUE DYNAMICS

Who is in the room, what are we looking at, how are we looking at it?

A critique happens when a group of people convenes in an art studio or critique room to discuss and evaluate works of art. Depending on the class level, the school's resources, and the area of study, the group is comprised of a combination of students, one or several instructors, and sometimes other invited participants, usually thought of as experts. That's the surface view of things. But many unseen variables come into play as a critique unfolds. More often than not in beginning classes your critique will be conducted by a single instructor, and the work that's put up will be a group of individual responses to a common assignment. But in intermediate and advanced-level art courses, and certainly on the graduate level, the faculty/student ratio is inverted so that it is not uncommon to have five or more faculty members conducting a series of fairly lengthy critiques for single students, either in isolation or among peers.

Critique as Theater

A critique can be seen as theater and much about it resembles performance. Instructors and students can take on guises in critique that seem at odds with their everyday personalities. Verbal exchanges can be conversational, argumentative, tangential, or disconnected. Sometimes comments are delivered like rhetorical declarations, other times mumbled and drifting. Body language is in play. Sometimes your fellow students will listen intently and other times look aimlessly around the room. When a student is being critiqued some will actively

engage in eye contact while others will tend to slump and duck in the corner. Pay attention to your own body language and that of your fellow students. Are you projecting confidence or defensive bravado? Are you naturally less talkative than other students or are you acting deliberately disengaged?

The critique is also a kind of game, not because it lacks seriousness but because it operates with a set of mutually agreed upon rules of engagement and criteria. These vary according to your instructor's views about art and her approach to structuring the critique, the dynamics of the critique group, the level of the class, and the purpose of the assigned project (if any). The critique also takes place within the larger context of contemporary artistic practice, itself a pluralistic patchwork of often competing discourses. When the critique format and its criteria reflect a particular approach to assessing art, as is often the case, then unspoken assumptions about what constitutes legitimate art practice come into play.

The Art Object Is Not Absolute

When an artwork is presented for critique, a variety of variables inform the way it's perceived. There is the work that is physically in front of us and our individual interpretations of it. We can see it in relation to other works the artist has done, and ask if the work shows any evidence of progress, or even if the work offers a solution to problems raised at the last critique. It will inevitably be compared to the other works in the room and then in relation to other works in the surrounding art world and in art history.

The Language of Critique

An artwork is commonly described in critique as *working* or not *working*. Aside from the fact that we use the verb to describe the noun, *working* evokes odd images of something efficient, industrious, and effective, in contrast to something lazy, ineffectual, or uncooperative. Should we imagine it as working on us? Or is it working harmoniously with other elements in an aesthetic structure? We instinctively feel that we all know what we mean when we say, "that works," or "that doesn't work," and we feel comfortable using such language without really thinking about what we mean.

Critiques are often full of militaristic language: *defend your work, struggle with the painting, attack the canvas, execute the piece, wrestle*

with it, master the medium. Instructors have even been known to instruct students to think of the painting as an *opponent.* Are these terms too loaded? Do they necessarily refer to a masculine viewpoint as some critics claim, or do they appropriately reflect the difficult nature of giving substance to an idea?

An instructor who thinks of a painting as the result of an authentic creative act might use language that points to the act, such as, "You didn't know what you were doing in that area," or "you weren't really *painting* here," or "this work lacks commitment; you're only painting effects; this is false; I don't buy it."

Listen to the language in critique. Try to get a sense not only of what is being said but also of the hidden assumptions that lie beneath. No matter what the instructor's or visiting expert's own agenda (everyone has one), more often than not, she or he is pointing to something in your work that needs attention. Indeed good criticism comes in many guises.

Artist's Intentions

To guess an artist's intentions by looking at a work has never been a fair venue for critics or historians. It is too speculative, too subjective. Much contemporary art, nevertheless, is exhibited with supporting information in the form of artist statements and interviews. Add to that works that point directly to the artist, by means of biographical texts that are integral to the work, and the question of intentionality becomes unavoidable. In the art school setting, where the goal is to help students to realize their visions, a discussion of your intentions has a place, even if it can be both confusing and revealing. What you claim the work is about and what the critique participants see can be miles apart. However, clarity of intention can lay some groundwork for a discussion bent on helping you realize these intentions in the artwork. The formal means by which intentions are articulated become a part of the critique dynamic.

If your critique begins with you introducing the ideas that led you to make a work, intention overtly sets the tone for the discussion. If you have a relatively clear idea of what you are trying to do and can articulate that, the group can quickly determine if the work matches up. If it doesn't, discussion can turn on this disconnect, or the merit of the intentions themselves, or how to realize them better. But does it really matter whether or not the work and what you *think* you're doing have anything in common? Indeed, many artists (even famous ones) don't understand

their own motives and make work that belies their intentions in complex and interesting ways.

Instructors may refuse to hear about your intentions, responding to long introductory explanations with comments, such as "Your ideas are getting in the way." "The work speaks for itself." "You're all caught up in the ideas and not in the work." "I don't care about what you think you're doing, you don't know what you're doing," and so on.

Your instructor may ask you about your intentions, but even if you are particularly articulate, can we ever really know what they are? What we think we are doing in a work and how it's received publicly can be worlds apart. Intentions, if they do come up, will often be critiqued along with the work, and then taken with a grain of salt.

Cliché and Originality

When someone's work in critique is labeled clichéd, or references are made to another artist's work, the complex subject of originality will arise. This can be confusing. We praise originality, along with freshness and inventiveness, and yet we insist that to achieve these things one must be well versed in contemporary art and art history. Is this not contradictory? To avoid cliché, isn't it best to isolate yourself from all that influence? Wouldn't this improve your chances of creating something truly original? Doesn't the instructor's insistence that you look at so-and-so's work undermine your quest for originality? Are you not in danger of becoming derivative?

In fact, research into contemporary and historical art has the opposite effect. For in our daily lives, we are all surrounded by images and examples of art, whether we study it or not. Hence, we are continually being influenced not by creative interesting solutions, but by provincial, second-tier, watered-down examples of art. The result is that we are influenced, not to produce highly original inventive work, but rather to make work that resembles what we *think* art should look like, indeed, what we are used to seeing.

One way to understand this is to consider the music world. Imagine attempting to engage with an alternative music scene having only listened to your grandparent's country collection. This could be interesting in an oddball conceptual way, but your exchange will be a lot richer if you have studied and are familiar with lots of music, both mainstream and obscure.

This is not to say that art about art is necessarily desirable. It's simply that knowledge of your field enables you to be part of the larger conversation, to see your work as it will be perceived publicly. Thus, knowledge of the world and culture can only enrich you, whether literature, scientific study, personal experiences, or travel. Knowledge of historical and contemporary practice places you in a larger stimulating conversation. It can even make you bolder and more inventive. Worry less about being original and more about being informed. You will end up being less clichéd!

When the Format of the Critique Is at Odds with the Format of Your Work

Can a critique actually change or interfere with your work? For example, how do we critique a performance of uncertain duration? Or an off-site sculpture meant to be accidentally encountered? Is it better for you to construct an installation with imperfect lighting or with limited assembly time in order to get some discussion going? Or does it make sense to limit your efforts to the particulars of the critique space? A critique can at times become an odd parallel universe that exists to the side of your work.

For this reason, more and more documentation is ending up in the critique room. As discussed in the chapter "The Work in the World," off-site installations, private performances, or guerrilla actions, located at distances inconvenient for group critique, may need to be presented as documentary.

Whether you choose video, photographs, written texts, or artifacts, the format itself becomes a legitimate subject for the critique. For example, what size are your documentary photographs? How is the video edited and presented? Are artifacts from an off-site performance pinned to the wall or arranged in books? Is a chronology created? Do you attempt a recreation of the site?

Documentation and presentation act as records of an art event and become themselves the place of meaning. Where does the art occur? Is the video of a performance running on a gallery monitor the art? Or has the art already occurred in another time and place? Like old black-and-white photos of early performance art, what is exhibited in a gallery becomes the art, in that it is what we experience, in place of the event itself.

SURVIVING THE CRITIQUE

Leave Your Ego at the Door

The first step to surviving the critique is to leave your ego at the door. All critiques test your ability to occupy the paradoxical position of being, at once, committed to your work and detached in critique. Remember that you are not your work. Try to become an impartial viewer, standing *beside* rather than *against* the other members of the critique. Consider the criticism thoughtfully, as if the work in question was done by someone else.

Staying objective in the face of feedback from a single authority can be especially challenging, since the authority's point of view may seem subjective, self-serving, or unfair. Nonetheless, you are still likely to receive a great deal of useful information. You want to remain open-minded while at the same time hold onto your own sense of vision and purpose. You may be tempted to adjust your own work to what you think the instructor favors. This is ultimately unconstructive. Make sure that you are taking the information from the critique in an *active*, not a *reactive*, way.

Active and Reactive Listening

What do we mean by this? In a reactive response you *react* to criticism by either dismissing everything that has been said or by trying to please the instructor by following suggestions to the letter in spite of your better instincts. An active response, and a better way to deal with criticism, is to listen carefully, take notes, and isolate issues that have been raised. For even if you reject an offered solution, it may be pointing out a legitimate problem. The biggest danger in any critique, but especially in critique situations where there is a single authoritative instructor, is the tendency to see all criticism, positive or negative, as approval and disapproval, and to see comments as prescriptive orders. If you are criticized for something in your work, try and articulate *for yourself* what alternatives are open to you.

One way to approach a critique *actively* is to respectfully, but firmly, engage with questions. "Could you explain to me further why you think that? I don't agree that this was a poor choice of color, but I am open to reconsidering." "Explain to me a bit more about why you object." Even if the final result is still disagreement you have engaged in

a nondefensive manner, demonstrated that you are listening, and asked for some clarification.

This can be helpful also in critiques where you encounter wildly diverging opinions. When two respected instructors give you responses that are exactly opposite, do you close your eyes and just choose one? Instead, you must try to think through each of their arguments and solutions. Turn them over. Work through them. Go back into the studio and perhaps experiment with both solutions side by side. Often your eye will settle the argument.

Critical to a successful critique of any kind is an ability to detach yourself from your work. Again, comments—be they positive or negative—are not directed toward you. This is one of the most difficult things to grasp when you have just been working night and day to complete a piece. If you have been very involved, it is hard to suddenly separate from a work when you put it up for critique. But separate you must. Thus, in critique, you will look at your work side by side with the authority, almost like two scientists, objectively assessing what is before you. Stepping to the side to get out of the line of fire is crucial to absorbing what is observed and discussed.

Critiques of Class Assignments or Works Made with Specific Parameters

When an assignment contains highly specific project parameters, the critique is sometimes limited to a simple determination as to whether works do or do not meet the assigned criteria. For example, your entire class is given the same formal or conceptual problem to solve or a project that is material or technique specific. Every student in the class paints from the same still life or sculpts in clay from the model. Such assignments are often designed to test your level of proficiency in a given material or technique.

Thus, in critique much of the discussion is centered on how and whether the works demonstrate technical achievement in a common material or a process. Or in cases where the assignment is to explore particular formal or conceptual issues, a critique may focus on whether and how these are evident in the work. In critiques of assignments with clear parameters, if you produce an ambitious and even accomplished work that ignores the challenge of the project requirements you will likely have an unsatisfactory critique.

Surviving the Technique-Specific Critique

Preparation for technique-specific critiques is straightforward. First and foremost is the importance of understanding the instructor's goal in making the assignment. What skills is she trying to teach you? What concepts or issues does she want you to consider by asking you to implement this work? Make sure that you are clear in this regard! Many students can testify to the confusing experience in a critique when a skillfully realized work—one that has drawn universal praise from peers outside the classroom—is dismissed, while what looks to be an awkward, unsuccessful work is intensively discussed. Keep in mind that in these critiques the work is often operating in the service of a particular instructional mission. You may not ultimately work with these materials or processes, or have those issues in mind as you begin to develop your independent studio practice,[1] but the lessons that are taught through the completion of a project within stated parameters can inform later work in unforeseen ways. This will broaden the options open to you for realizing future work.

Instructors differ on how closely you are expected to follow the rules of their assignments. Some expect a strict rulebook response, while others strongly encourage a range of creative interpretations. What happens in an assigned project when the work takes a direction that leads away from the assignment? Given that any work can evolve in unforeseen ways, and indeed should, how do you best reconcile your own need for flexibility and still maintain the discipline to stay on track with the project parameters?

Critique Preparation Is Project Preparation

When a project is assigned, articulate in your own words, not only what you plan to do but also what skills you will employ. Review the project guidelines. Ask questions. As the piece begins to take shape, if the work appears to be diverging from the assignment, speak to the instructor. No effort is ever wasted, as anything you do can contribute to the totality of your studio experience. Nonetheless, this work might not be appropriate for the critique. Remember that the assignment is designed to offer specific instruction. When in doubt, check with your instructor. What seems to be at odds with the project goals may actually be a logical and useful extension of those goals.

Interestingly, you may find that as you begin to develop more independent individualized work, your approach to these early problem-

solving projects can be a clue to the kinds of processes that will be important in your own studio practice. You may find that you embrace the structure of predetermined goals, or that you writhe and struggle with what feels like a restraint on your free-flowing (and unpredictable) creative expression! The critique will be a kind of gauge of your tolerance for working within such restrictions, which you may encounter much later in the form of commissions or collaborative projects.

When Only Selected Works Are Discussed

Another scenario occurs when the need to critique the work produced by a large class overrides the possibility for group discussion. This could be called the *so much work, so little time* model. You may experience this critique as a blur of comments from the instructor as she races from work to work, or selects works, seemingly at random, from a wall of individual pieces hung salon style. In critiques like these, individual pieces are discussed as examples for the entire group and the public assessment of any particular student's work is less important than the presentation of various concepts.

As unfair as it seems, and indeed frustrating if your work is overlooked, this kind of critique is an extreme example of something that is part of the dynamic of *any* group critique. That is, you can often benefit as much from what is said about a fellow student's work as comments about your own. In this kind of critique you must reconcile yourself to the possibility that your efforts may not even be discussed. Nevertheless, it is crucial that you remain open to the information offered. This is one of the most important lessons to be learned in assuring a productive critique within *any* critique structure. Though the critique is an assessment of particular works, it is also a conversation where the work itself becomes a kind of entry point into a larger discussion.

On rare occasions, a visiting critic, curator, or artist will critique selective works, as described above, being available for only a limited period of time, in contrast to more accessible course instructors. This can sometimes give rise to a palpable sense of competitiveness in the critique, as students vie for attention. You should focus your efforts on installing or presenting your work to the best of your ability, and then come to the critique with as much detachment as you can, directing your attention, not only to what is said or not said about your work but also to the substance of the overall discussion. What is said to your peers probably applies to you.

WHO IS CRITIQUING YOU?

The Expert

Most critiques are led by a single instructor who moderates a group discussion and provides much of the commentary. In deciding to study art, you as a student have entered into an implied contract with your faculty. There is an understanding that your instructors, along with other experts invited to critique your work from time to time, come with experience in the field of art that is greater than your own.

Indeed, the word *expert* is related to the words *experience* and *experiment*, which come from kindred Greek and Latin words that have to do with trying, with implications of knowledge through trial and error. Hence, one definition for *expert* in the *Oxford English Dictionary* reads, "one who has gained skill from experience." A second definition calls the expert "one who has special knowledge causing him to be regarded as an authority."[2] It can be helpful to consider the kind of special knowledge that this *expert* brings to your critique.

Instructors and guests alike have different sensibilities, interests, areas of expertise, and even politics. Whom do you listen to? How do you select what is useful? How do you make sense of the opposing views and seemingly irrational praise and censure that come your way? We've attempted here to create loose portraits of some of the most common experts that we've encountered both as teachers and students. Of course, most experts are composites, embodying the qualities and critique styles of more than one of our types. Still, an understanding of the differences between and motivations of various experts can perhaps help you glean the message from the medium, and thus make more sense out of your critique.

The Absolute Authority

Many critiques, especially in beginning studio classes, are run by an absolute authority—the instructor. Students put work on display and the instructor does most of the talking. This model operates on the assumption that a work of art demonstrates discernable skills and structural integrity that can be identified either as the successful expression of your virtuosity and attention to conventional notions of craft, or that it at least contains some qualities, identifiable by the instructor, that verify its success. Discussion is often centered around formal elements and

craft issues, but can also be rooted in a perspective born of your instructor's own artistic practice or eccentric and subjective responses. The authority here is the instructor, and his or her voice remains unopposed. Work will be praised and censured according to your instructor's own criteria.

The Connoisseur

You may encounter an instructor who uses phrases like "this *works*" and "this does not *work*," with little explanation for what this means or why it is so. This kind of instructor might be called a *connoisseur*.

By definition, a *connoisseur* is someone whose expertise is the result of some innate gift or learned ability to see works of art with a rare, sensitive *eye*. The connoisseur has discriminating taste and an eye for authenticity. The beautiful, the harmonious, and the appropriate are critical standards for the connoisseur, whose experienced eye knows how to discern "that which is good, that which is bad, and that which is indifferent."[3] Historically, artists have worked under the guidance (or tyranny, depending on your perspective) of connoisseurs. And collectors still rely on connoisseurs to assess the aesthetic and market values of artworks. Although it's easy to picture an antique character complete with monocle and bent back, inspecting a dusty painting, there are indeed connoisseurs of contemporary art with a *taste* for the present or even the next thing! These new connoisseurs will be steeped in a knowledge of contemporary art practices, to which their tastes and discriminating eyes are always attuned. In each case, your work will be judged by predetermined criteria that might seem mystifying to the uninitiated. At the end of the day, the new connoisseur is the same wolf in sheep's clothing, so let us go back to the classic discerner of beauty and authenticity.

Our old-style connoisseur comes to a critique with predilections for particular styles of work and critique criteria that are informed by notions of craft, authenticity, as well as conventions of beauty and appropriateness, the assumption being that these qualities are readily apparent to the trained, sensitive viewer.

A connoisseur-led critique can produce interesting debates about defining and setting criteria for beauty and skill. Whether the connoisseur's assessment of the work in critique is merely a subjective response, disguised as expertise, or a true recognition of student achievement (or lack thereof) will be up for debate. This brings up

a few questions worth considering. We might ask, for example, if and how we can define beauty. Is beauty a universal quality readily accessed by anyone or is it specific to a given historical period or culture? What words do we use to describe a work of art to which we have a vague positive response? Are their set criteria or standards for giving a work a thumbs-up or thumbs-down? Or is the reception of art by its nature subjective? How does taste factor into our choices in making and judging art? Is taste a skill? Can it be learned? Must it be learned? Is it important that our work be beautiful? Or refuse to be beautiful? Can disturbing content be beautiful? Should it be? How does the concept of the beautiful relate to the concept of the sublime? Can one back up declarations such as "this is beautiful" with evidence of some kind?

That One's a Dandy

A friend described a painting critique she attended at a prestigious summer art camp. A famous New York artist was invited to critique, and all of the students were in their places with works ready to bring up, as called. One work after another was brought to the front for critique. Each time the visiting artist said, "I don't have anything to say about that one. What's next?" When the next painting was put up, he said the same thing, "Nothing to say about that one. What's next?" This went on for some time until, after a long series of dismissals, a painting was put up that gave him pause. After looking at it for about twenty seconds, he stroked his chin and declared, "Well, now that one's a dandy."

The Judge, the Evaluator, and the Specialist

Three common experts encountered in critique are the *judge*, the *evaluator*, and the *specialist*. All critiques involve the judging of work, but an instructor who appears to operate with some degree of detachment and without an obvious predetermined position might be thought of as a *judge*. A judge presents opinions with some logical argument in support of her position and no style appears to be favored over another. The judge weighs the *evidence* and her assessments are balanced between positive and negative. *Evaluators* are similar to *judges*, but the evaluator's assessment of work is driven by a clearly stated and objective set of criteria. *Specialists* have a particular expertise in a given field. This may be special knowledge of a material or process or some unique life experience.

Surviving the Judge

Commentary from *judges*, *evaluators*, or *specialists* may be easier to comprehend and process because it seems less arbitrary and subjective. An instructor, whose every negative comment is balanced with a positive one, who swings between two poles, from comment to comment, before summarizing a ruling declaration, might be called a judge. If you hear something like this in critique, how do you react? "Your carving skills are evident, but you have lost the proportion of the figure here (pointing to the thigh), and she looks to have a lump on her forehead, which could not have been intentional. But the form does show a sensitive use of the natural grain of the wood, so all in all I think it is a good beginning." Or this? "Your use of mirrors to reflect the projected video images around the room is inventive, but the wires that the mirrors are suspended from are distracting, and I like the way that we see fragments of the body in the mirrors, but I think the gestures could have been more developed. All in all the video installation is ambitious."

In some instances you will agree. (You already knew that thigh in the carving piece was a problem and struggled with it all week. You already knew the mirror-hanging device in the video piece was a disaster.) You may disagree. (Actually you had planned to paint the wood and ran out of time, so you actually have no interest in the wood grain. You think the gestures in the video are subtle and just fine as they are.) Ask yourself if such an assessment contradicts or affirms what you already know. If some aspect of your work has been judged deficient, reconsider and reexamine these parts of the work. Do you only hear the negative criticism? Only the positive?

Surviving the Evaluator and Specialist

Evaluators and *specialists* tend to operate out of clearly stated criteria, which are often encountered when assignments are goal specific. For example, if your drawing is being evaluated according to its mimetic function, *likeness* is the measure. It is straightforward enough to evaluate a well-drawn arm, a foreshortened figure, a still life with a single light source, or a landscape with atmospheric perspective. However, if your assignment, for example, is to make a sculptural work that resists reference, or uses one material, or involves three kinds of joinery, then the work will be evaluated according to its adherence to the goal.

A *specialist* operates in a manner similar to that of an evaluator. These are typically instructors with expertise in particular areas to the exclusion of others. *Specialists* work best in the context of very specific assignments with clear goals. Critiques will be focused on how best to implement a given technique, and much of the critique discussion and feedback directed at the particulars of specialized materials, media, or processes. Your instructors who are most confident addressing media-specific issues or technical problem solving in critique usually conduct themselves as *specialists*.

Keep in mind that most *specialists* will be focused on a particular aspect of your work. If you can identify the expertise of a specialist and engage her on *those* terms, you will add to your knowledge base tremendously. If you try and force a specialist to address issues outside her area of expertise, you may end up feeling frustrated and shortchanged. Whether a matter of interest or self-confidence, some specialists will all but dismiss approaches that do not involve their own materials, processes, or formats. Again, it is best to identify the specialist's contributions—whether very particular technical knowledge or life experiences—and tap into *those* resources. Remember *any* critique is a small fragment of a much larger body of information that you will encounter over time.

More Authorities: Narcissists, Drill Sergeants, Unconditional Supporters, Theorists, and Philosophers

The kinds of authoritative voices that you will come across in critique are infinitely variable. Let's identify a few more and discuss how to recognize and be better prepared when you encounter these experts and their approaches. Bear in mind though that these are not hard-and-fast categories and that many classroom authorities embody qualities and share outlooks across the categories.

The Narcissist[4]

The *narcissist* is inclined to praise and censure work according to how well it mimics his own, both in look and in method. The narcissist-conducted critique is typically a performance. The critique is an event, a reward to initiates for all their hard work. It's a place of public

humiliation for the lazy, the untalented, and the non-believers. The criteria vary according to the specifics of the narcissist's own practice, but his work is always the standard and the goal. Students are often invited to speak once they've established that their views are in tandem with the narcissist's or as foils against which he can argue his own points.

Surviving the Narcissist

The narcissist's power is such that it can be difficult to recognize it when you're under his spell. Warning signals might be if you're finding that the decisions that you make in your work rely almost exclusively on *his* eye, even what you imagine he would think or say. You also like the comfortable feeling of his clear and unambiguous *answers*. (So many other teachers seem to answer your questions with questions!) When you encounter a narcissist, an important thing to be mindful of is a feeling that you've lost your own center. You've given up your own power and judgment and are relying completely on his. To regain your center, try to actively pursue a wider range of perspectives.

If you are *not* an initiate and, for scheduling reasons, you find yourself in the class of a narcissist and his followers, you may feel like you woke up to discover that you joined a cult in your sleep. In this situation, the best thing is to try to learn what you can, knowing his way is one among many.

Drill Sergeants and Unconditional Supporters

Two more variations are the *drill sergeant* and the *unconditional supporter*. The *drill sergeant* uses his voice of authority to challenge the student. In this case, the particulars of his criticism are less important than the fear he inspires. Dreading public judgment and craving his approval, you come to the critique with your best efforts. But the *drill sergeant* is never satisfied, and this only whets your resolve to try even harder. It's the "I don't think you can do it!" approach. What the drill sergeant *really* believes about you may remain a mystery. The specifics of the drill sergeant's criticism may not even be important. To be effective, all the drill sergeant needs is for you to maintain, at least for a time, the vague feeling of not having done enough. When, at the term's end, the drill sergeant is pleased, many students leave with a sense of tremendous accomplishment, often crediting the drill sergeant with this success.

Trashcan

In a senior critique class the instructor comes around to a sculpture that the student has been tirelessly working on for weeks. After glaring at it for a few moments, he points at a red metal trashcan in the corner of the room. "See that trashcan over there," he growls. "That trashcan is better than your sculpture! At least that trashcan knows what it is!" The student is devastated. Years later she recalls the incident and realizes that her gruff professor was *really* saying, "Look at the clarity of that red trashcan in the corner over there. The person (or machine) that made it did not hesitate for a moment. It was made with a clear purpose. It embodies that clarity. When I look at your sculpture I am confused. It has no internal logic that I can discover. I don't understand your decisions."

The flip side of the hard-to-please *drill sergeant* is the *unconditional supporter*. An authority figure offering unconditional support defuses any argument and derails any real criticism in the critique. At the heart of this model is the insistence that all art making is a creative act and that only positive reinforcement is constructive to the confidence that one needs to tackle studio challenges.

Surviving the Drill Sergeant or the Unconditional Supporter

Needless to say a critique with either a drill sergeant or an unconditional supporter can work wonders or be completely ineffective. Do you need a kick in the pants or a bit of encouragement? An instructor who personifies a drill sergeant will inspire and motivate you when you need a particular kind of challenge, but if you are, for whatever reason, less resilient you can become demoralized and discouraged. The danger also exists that you will end up working for the critique in order to please this authority figure and not develop a real sense of self-motivation. The tough love approach of the *drill sergeant* may be appropriate at some stages in your studio growth and not others. Some experienced artists maintain that such strict discipline is needed early on in the game; others assert that beginning artists respond better to criticism that gets increasingly tougher as confidence develops. Let the drill sergeant motivate you and accept his challenges, but remember that you are not making your work for him.

Supportive remarks may be appropriate to build confidence, but if overdone and not balanced with criticism such remarks will seldom

serve you in becoming a better artist. Critiques built entirely on feel good supportive remarks can also lead to an attitude among the group that the critique is meaningless.

When it comes to praise in critique, you may find that the drill sergeants are sometimes revered simply because they are so stingy with praise and unconditional supporters distrusted because they are so loose. Try and separate out the substance of what each says from individual personal styles. The merit of either positive or negative comments in critique is not necessarily linked to their frequency.

The Philosopher and the Theorist

The philosopher gets his authority by always relinquishing it, whereas the theorist uses his language as power over the group. Both see the work being critiqued as an avenue for illustrating theoretical constructs or philosophical questions. For the theorist, your work is another proof of his or her carefully constructed worldview; for the philosopher, it becomes a permission slip to ask interesting abstract questions. Critique discussion with philosophers and theorists can be some of the most interesting and some of the least useful. You may well leave the critique room feeling stimulated and even enlightened, and then find yourself in the studio without concrete solutions for your piece. Philosophers are often more pleasant than theorists, who may turn against work that doesn't fall within specific conceptual constructs.

Because philosophers and theorists tend to critique "to the side" of the work and direct most of the discussion to ideas in which they have an interest, the best way to deal with either is to redirect the conversation back to what is front of you. That said, if you are willing, you are likely to finish the semester with a great reading list.

Visiting Artists, Curators, Gallerists, or Critics

When a visiting artist responds to your work in a studio visit, the result can and should be a mutually stimulating conversation. The studio visitor is reacting to what he sees in the studio without any prior knowledge of your work. Often the visitors are not educators and are unaccustomed to looking at student work or even work in progress.

Such visitors are notoriously unpredictable. Some ask you questions to open a dialogue; others deliver a well-articulated (or not-so-well-articulated) opinion. Others peruse the work silently, leaving you in awkward anticipation. The advantage of a visitor, who is meeting

you and your work for the first time, is that there is the possibility for a brutal honesty in his reaction, no matter how off the mark it may be. It is a valuable lesson in preparing for studio visits with curators or gallerists in the future because it forces you to consider what to present and how you want to organize your work.

CRITIQUES WITH MULTIPLE EXPERTS

The United Faculty Committee

Faculty groups usually operate with multiple voices, and we will discuss these later, but in some situations they all speak from the same perspective. We might then think of them as a *united faculty committee*. This is a group that critiques from a shared position and may be comprised of individuals who have a common worldview or ideology. You will most likely encounter a united faculty committee at an institution where curriculum is informed by a very definite canon, such as continental theory, formalist painting and sculpture, or academic figurative traditions. However, a united committee also occurs when members of a group all hold in common certain conventions particular to a given medium. "Clay should always be glazed, never painted." "Dovetail and dowel joints are superior to nails." "Paintings should always contain six tones for modeling light and shadow."

Surviving the United Faculty Committee

The united faculty committee, as the name implies, can be one of the most intimidating, if the group has already reviewed your work in your absence or if you are asked to defend your work before the committee. Common at end-of-term candidacies or as a gateway to admission to an honors program, this experience differs from a critique, where a group of faculty (and perhaps students) gathers in your studio to discuss your work. This group tends to speak as one, with members echoing each other's points and reinforcing a collective position.

Given that the united committee speaks with one very powerful voice, it is difficult to contradict. You are not only outranked but outnumbered. How do you participate in such an experience? The best strategy is to get your bearings and approach the situation with objectivity. Then *listen*. If possible, respectfully but firmly engage the panel by

meeting its declarations with questions. Note taking is an excellent tool. If the observations are constructive but confusing, you will have a wonderful record of what actually happened when you are no longer distracted by being on the hot seat. If the comments turn out not to be constructive, you will at least have had something to do with your hands and been able to feign interest in the face of hurtful or disagreeable jpronouncements.

A Constructive Response

If your work is critiqued from an ideological position that you do not share, your best defense is to try to understand that position. Get the reading list for goodness sakes and find out where these people are coming from! Let's say that you are working on large painterly field paintings and you encounter a group of faculty that clearly seems only to like photographs with texts, which explicitly address social issues. Will any of these people help you to be a better painter? Perhaps not. Will you learn more about why your self-referential painting is so annoying to them? Will you come away with a clearer understanding of what it is you are doing? Will you stretch your own definitions of what art can be? Probably. Or alternatively, you find out that the committee only accepts photorealistic figure painting and censures any form of abstraction. Your research will help to clarify the hows and whys of what you are up against.

What if each day, on your walk to school, you collect a small discarded object that you find along the way. You present these at the end of the semester with small stories attached. The panel critiquing you—all dedicated builders—dismisses your work. How do you respond? Your best tactic is to encourage them to articulate exactly why craft should be favored over found objects. Ask individual panel members why they have such objections to the work. Is this particular action of collecting too obvious or is it just undeveloped in the work? Is there a fundamental problem with the *idea* of found materials or is this work just not labor-intensive enough? If it's the latter, is labor quantifiable, and is it a fair benchmark for evaluating work? As long as you see the critique as an opportunity for discussion, even ideological incompatibilities can become opportunities for understanding your own activities. Your differences may remain irreconcilable, but if you emerge from the clash with the ability to better understand and articulate your position, the critique experience has not been in vain.

A Brief Note on Shared Worldview or Ideology

Ideology, a word that encompasses a range of meanings and usages, is loosely used here to mean a hidden structure of beliefs and values that shapes the way we think, act, and understand the world. For many students this will be an unfamiliar word and one that seems puzzling when applied to the critique. But its usefulness as a term has everything to do with how we assess the world around us, and this, of course, includes art.

As one encounters various authoritative voices in critique it becomes more and more evident that strong positions are seldom grounded in simple matters of preference or taste, but rather in personal belief systems. If a student who is operating out of a perceived quest for universal beauty puts work before a committee or faculty member who regards such efforts with suspicion, the student will face an ideology gap. An instructor who came of age in the politically active youth culture of the late 1960s, for instance, might find it difficult to appreciate reality television.

Whatever experts you encounter in critique, consider the criteria that they use to assess work, and pay particular attention to the language they use. As always, take notes, even at critiques of the work of your peers. Identify the terms used and research any that are unfamiliar to you. You may determine that in critique one approach has been privileged over others. Try to identify and differentiate ways of seeing and discussing works in critique.

Multiple Voice Critiques

Multiple voice critiques operate on the old Socratic principle that dialogue is a means to wisdom. Not that strict Socratic dialogues are occurring, but it is through dialogue that we can unpeel the layers of meaning, the problems that need fixing, and the possibilities for future work. Dialogue—which literally means in Greek *through* (or *by means of*) *words* (or *speech*)—can be messy, especially as more and more people engage in it. But it is through the contradictions, the defining of terms, the exposed nuances that we begin to see beyond the obvious, the ideological, the narrow present.

Faculty in Groups

One of the most common venues for critiquing is the often cobbled-together group of faculty and visitors found in upper division and graduate critique rooms. This group of voices, often with widely different

views and experience, comes together in a space to engage with your work. Some are members of a standing committee that meets more than once to follow your progress; others are invited artists and critics, thrown into the mix for a particular critique event. You will also encounter faculty groups in schools where team teaching is employed and where special critique sessions are held and structured into graduate studio programs that assess work at scheduled intervals during the course of a two-to three-year program.

Every faculty group has a dynamic all its own, which varies according to who's in the group, the combined personal dynamics, and the changeable moods of its members. Faculty participants within a critique group may have greater or lesser degrees of familiarity with your work and have wildly divergent comfort levels with particular forms of contemporary art. Some come to group critiques with the candor and enthusiasm one might bring to a lively intellectual conversation among friends, while others struggle to find a rhythm, or even be heard, in what can seem to be a jumble of competing voices.

Critiques by groups of faculty can be some of the best and some of the worst experiences for you and your faculty alike! One would think that an assembly of experts, all focused on your work, each bringing to bear his or her experience, insight, and expertise would be a sure formula for a successful critique. Why then are some group faculty critiques so rich in information and others totally maddening? Part of the answer lies in the group dynamic and part in the lack of clear structure and leadership. Participants come and go, there is no formal order that designates who should begin and with what topic. Some like to show off, others to hold back. Some are simply bored, whereas others have their own agendas to promote. Be aware that a faculty group in critique is often a freewheeling unpredictable creature! Don't take offense if the conversation veers away from your work and takes on a life of its own or if your work is met with awkward silences. This is as likely about the dynamics of the group as it is about your work.

Single Voices in Faculty Groups

At times you will encounter instructors or other experts, accustomed to critiquing alone, embedded in a faculty group. They will participate in ways that assure their independence and authority. A *judge* may avoid the chatter and fray of disagreement during the critique until the end, where she will offer a summary of the proceedings and perhaps a final

ruling. A *connoisseur* will make subjective declarations particularly on matters of aesthetic value in tones that seem to say, "But is this not evident to *everyone*?" A *specialist* will either limit his critique contribution to a few comments that address his particular field or doggedly continue to pull the conversation back to his area of expertise. A critique full of single-voice authorities can become a cacophony of monologues, where everyone is talking and no one is listening.

Surviving Faculty Groups

When a faculty group assesses your work the results can be confusing, particularly because this is a group of *experts*. The faculty group is made up of individuals, who are each a rich source of information. One can solve any technical snag, build anything, and give you the phone number of the place to get the parts. Another will seem to have read every text in the Western canon, including much of the contemporary fiction written since last week. One has traveled the world, has seen every Biennial above and below the equator, and holds her own when debating art theory. Another seems almost psychic, saying things about your work that you sense are deep, but aren't sure why or how this will help. How do you sort out statements coming from so many perspectives? How do you reconcile contradicting opinions? How do you organize information that ranges from highly specific technical advice to relevant quotes from obscure novels or theoretical texts, to fascinating and eccentric subjective responses? How do you process so much information period? After all, while all this is being thrown at you, you are standing next to your private labors made suddenly public! The only solution is to make a record of it.

Collecting and Processing the Data

Take written notes, have a friend do it, or even audiotape the critique. Documenting can and should be done no matter what kind of critique you find yourself in, but is especially useful to sort through the richness and variety of information that may be thrown at you from a group of faculty. This will not only be a record that allows you to reconstruct what has been said in a specific critique but also will be a diary of what was said in the last one and the one before that.

Identify contradictory comments made in the critique and place them side by side on a page. Do these differing viewpoints share some identifiable issue? Can you articulate what is being questioned in your

work? Is there a single issue that acts as a kind of magnet for these contradictory comments? Do two of your instructors really present opposing positions, or are these just nuanced versions of the same criticism? If each instructor has proposed a different way in which you might have made your work differently, you will likely feel pretty annoyed. List these suggestions and identify commonalities. Even if a particular solution may seem unacceptable the fact that the suggestion has been made can also direct you to a problem area that needs to be considered.

Try to determine whether the same complaints seem to come up again and again. Are you told in every critique that you overwork your paintings or that your surfaces are too thin? Is the group always interested in the ideas you raise in your found object box constructions, but inevitably the discussion turns to the loose hinge or badly painted edge? Is composition always mentioned, or scale, or palette? In every painting you present, do instructors begin to talk about what is going on in the scene, only to soon start fussing about the figure's anatomy? Are you asked why you never use color, why you always choose found objects of a certain style?

How will you improve your figure drawing skills, or is this really an issue? Do you need to stand firm in your use of digital effects in the transitions, or should you reconsider? Do you need to spend more time on details like fasteners and nails even when you are impatient to get on with the idea, or are all these craft details irrelevant?

Do some topics always come up in your critiques, topics that you believe have nothing to do with your work? Can you identify a position to contextualize your work that may be opposite to how it is read by the critique group? Ultimately, you must determine how to use this information.

Take a look at phrases and statements made in the critique. Out of a list of seemingly disconnected statements, you may be able to construct some coherent conclusions. Sometimes a critique discussion continues over the course of several critiques. Sometimes an odd observation becomes relevant not with the next work, but after ten works! The important lesson is to see the critique as an active conversation.

Tiny Sculptures

A student presents five tiny sculptures to a faculty group. The work is a collection of five beetles that have been dressed in red and gold embroidered capes. Everyone in the group is drawn in to look closely and declares them to be beautiful.

"Yes, they are lovely," says one instructor, "but they just die on these big pedestals. I think you should build your own bases — tall very thin ones."

A line of questioning follows around embroidery techniques. Someone then asks, "Are they *real*?" A participant offers that he would like to see the sculptures presented under a theatrical spotlight. A side conversation develops among some faculty about another artist who works with miniatures.

"What was her name?" they ask one another.

"I think you should figure out a way to add a magnifying glass to the sculpture," says one instructor, and later in the critique finishes the thought with, "Have you thought of taking macro lens photographs and presenting those, or projecting them?" A discussion then follows on the practice of making sculpture as photographic props. Is this a good thing or a bad thing?

One instructor calls it a sneaky way to avoid rigorous craft. "Hollywood fakery!" he declares.

Another has reservations about this solution, but for different reasons. "I am so *over* the make a small sculpture and photograph it so it looks big thing!" The critique ends with a discussion on the general topic of insects—likes and dislikes—and everyone's personal memories.

As the group breaks up an instructor, who has up until this point been quiet, weighs in with, "I think these insects are just too small and you should work bigger."

Though contradictory, it's easy to see how all these comments address scale and presentation, which for most of the faculty was the least resolved part of the work but never articulated specifically. If these comments are scattered among stories about insects, questions about how the works were made, or mentions of contemporary artists working in miniature, they might seem disjointed. A written document allows you to look more objectively at the information and to organize seemingly contradictory or unrelated suggestions.

Faculty Moderated Group Critiques with Student Participants

Unlike the critiques above, conducted by authorities whose effectiveness relies in large measure on personal charisma, an active faculty moderator will respond directly to the dynamics of the group. Because the active faculty moderator is leading your critique with a less authoritative voice, the success of the critique is particularly dependent on your active participation.

How much your instructor-moderator intervenes varies. Some will simply walk into critique and ask you to begin. This might be called the "throw 'em in the deep end and see if they can swim approach." If many of you are silent, so be it. If *all* of you are silent, so be it. (Some instructors will show a remarkable ability to let the whole room hold silent until someone speaks up.) If some students are domineering, so be it. If a clique develops and gangs up on a student whose work is deemed objectionable, so be it. Anything short of physical assault is fair game. The potential for high drama makes this approach to critique a favorite for some students and a nightmare for others.

Most faculty moderators, however, will utilize some kind of a structure, even if a loose one. If the critique is flat because everyone is disengaged, too worried about being polite, or just inarticulately mean, your instructor may direct your critique with a question to set the tone, call on selected students, guide a line of inquiry with follow-up questions, move the discussion away from a tangential conversation, or reintroduce a point that has been dropped prematurely. Sometimes role-playing, writing assignments, and other creative strategies will be used to facilitate more informed and active participation between you and your fellow students.

Related Lessons

Though some faculty moderators prefer not to interfere with any immediate readings at the onset of a critique discussion, others find that framing the discussion of a work around pertinent topics allows for more substantive dialogue. Before posing questions, your instructor may frame the discussion by introducing ideas that are invoked by the work at hand, be it a link to current art practices, a social or political issue that needs some explaining, or an artist's explicit use of poetry. This broadens the context for the discussion of a particular piece by defining the way in which it is in conversation with other works being made.

Your Responsibilities When Working with a Moderator

Once acclimated to the democratic feeling of a moderated critique, you may actually begin to resent the kinds of controls the instructor brings to bear. You may wonder what a discussion of contemporary art has to

do with your work, or feel that you are beyond having what is some-times basic information fed to you in such a manner.

Try and understand that your critique group may be made up of students with widely divergent communication styles. Some students may be less confident than you and need practice articulating ideas and building vocabulary. You will each come to the critique with unequal degrees of familiarity with art history and contemporary art. This kind of framing of the critique discussion is an introduction to the notion of art as an entry point into ideas.

Big Kids on the Playground

Don't assume that everyone in a class has the same level of familiarity with a given artist's work or kind of work. If you happen to be especially knowledgeable about an artist or idea relevant to the discussion, then engage with the group from this vantage point.

All too often arrogant students with a thimbleful more knowledge than their classmates engage in the cheap thrill of intimidating the less experienced "younger kids" on the playground. If you are the more experienced student, try to conduct yourself with dignity and generosity in critique. If you are the unfortunate recipient of such bullying, remember that doing well is the best revenge. Work hard. Focus on what you are doing. In case there is merit to the cruel comments, try to separate out the value in the message from the boorishness of the messengers.

Also, as you develop your own studio practice, you will find your-self drawn to research, read about, and see work that is not the same as that which interests your colleagues.

A Note on Critique as Democracy

If we think of a critique as a democracy, then everyone has an equal voice. There is no authority, and everyone—students and instructor alike—contribute to the discussion. The question arises, "Is every-one's opinion as good as everyone else's?" If some students are more perceptive, more informed, or more articulate than others, how can a democratic critique facilitate open but informed dialogue? Like a democracy, the model relies on rules of order and an informed citizen-ship. This is a good argument for fully participating in the critique whatever the format the instructor uses and completing any prepara-tion assignments.

NOTES

1. Using the term *studio practice* may seem unnecessary and even pretentious. Why not refer to this thing that we do simply as our *studio work* rather than risk evoking law firms, violin lessons, or yoga retreats? And yet these associations are appropriate to a particular way of thinking about the creative process. It implies some sustained repeated activity, an activity that is the opposite of random experience or dabbling. (Even a studio practice that is defined by random experience is one that posits a sustained investigation of random experience as its mission!) And there is a sense of commitment attached to a statement such as "the daily practice of painting." Consider someone who defines herself as a *practicing* rather than nominal member of a religious community. How a yogic practice as opposed to a yoga lesson suggests a deeper level of experience. Even the word's association with sports suggests mastery through a kind of knowing, not only through the mind but also through the body. For artists, it can mean a kind of intimate familiarity with a material, a way of moving, mark making, even selecting or sampling that implies a training of the eye through *practice*.

2. *Oxford English Dictionary*, Oxford University Press, 1971, Nineteenth printing in the United States, March 1980.

3. Ibid.

4. In Greek mythology, Narcissus was a boy so beautiful that when he looked in a pool and saw himself reflected back, he fell in love with his own image. He finally pined away and died of love for himself.

Chapter Six

CRITIQUE PREPARATION AND EXERCISES

PRESENTATION

Presentation Is Everything

A critique is like an exhibition. Out of the studio the work must stand on its own. At the scheduled time for critique, all work should be installed and ready to discuss. Nothing will be more annoying for your instructor than to begin a long critique day by waiting for you to hammer a nail or find a base.

The best way to avoid this scenario is to know in advance how you will install your work. If you are hanging a painting, get the necessary hardware and invest in a small level. If your sculpture requires a base, either construct your own or make sure the school base is painted and the appropriate size for the work. Shabby pedestals or those with wet paint are not acceptable. In short, do all troubleshooting before the critique begins.

Lighting

Lighting is important but can vary greatly. Some schools have critique rooms or areas equipped with gallery lighting, while other critique spaces make do with harsh overhead fluorescents. If you are fortunate enough to have the option to use spots, floods, or other considered lighting options, take full advantage of this learning opportunity. Again, plan ahead and set aside enough time before critique to light your work. Often this will complete the work in unforeseen ways. If you are stuck with overhead or fluorescent lights that do not enhance your work, you might consider experimenting with inexpensive clamp-on lights.

Title Cards

If there is outside information critical to the reading of the work—for instance, the found objects that you display were all collected on specific paths in the city, or the geometric abstract painting is actually a graph drawn from statistics on alcohol abuse—then you must consider ways to communicate this information. This is necessary even if you plan to stand in front of the work and introduce it to your classmates.

One solution is to make a small title card, a convention routinely adopted by galleries and museums to contextualize works in significant ways. As we discussed earlier, a black square painting called *Untitled* is read very differently than an identical one titled *Sample of Coal from Toxic Site 284*. You may also relay important information in the title card by listing the material. The same painting we called *Untitled* will change meanings if the medium is listed as *sampled coal from toxic site on canvas*.

Introducing Your Work

You may be asked to introduce your work before the critique begins. This can be useful if there is information not immediately evident in the work. For instance, if something occurred in the process of making the work, that information is critical to its meaning. Some instructors want this information to be included as part of the presentation, perhaps through title cards, wall text, or handouts. (Rarely will an artist be able to stand beside a work on exhibition and explain it.) Other instructors who think of critiques as forums for discussion will freely grant the right to frame the conversation about your work, rather than stand mutely by enduring a guessing game from your classmates.

If you are asked to present your work, ask yourself if you are giving a long-winded explanation full of excuses and descriptions of failed intentions. Are you insisting on the obviousness of obscure references that no one else sees? Are you explaining what the work *means* without regard for what it communicates?

Preparing Your Introduction

If you have been asked to introduce your work in critique, or if the typical format in your class is for the artist to say a few words before a work is discussed, there are a few things you can do to prepare. First, articulate for yourself what you think are the critical issues in your work. What technical problems did you struggle with? What were you

reading at the time the work was made? What sources inform your work? Consider also what questions you may have asked yourself in the studio. In other words, *you* frame the discussion. Try to refrain from long explanations that do not open dialogue. Focus on questions, not claims.

During critique, follow up comments with questions. Ask your fellow students to elaborate and clarify. Don't be afraid to ask, " What do you think about this?" Point to what you think is a trouble spot. Engage in the dance; don't dodge the jabs.

Intentionality is a complex thing in art making. Sometimes what happened against your will is better than what you desperately wanted. (If only you can see it.) Listen carefully to the comments and engage them. Not with excuses or regrets, but with an open mind. Try to see what everyone else sees. The most important thing you can do here is really listen. The gap between what you think you are doing and what you are actually producing can only be bridged by stepping to the side and trying to see your work as it is.

Artists and Writing

Writing has always had an odd relationship with the visual arts. While writers and artists have sat in cafes together, collaborated, and even married one another, writers, critics, and the public in general have regarded artists who write with suspicion. The idea is that artists are good at what they do *because* they can't use language like the rest of us or, at least, that the one gift precludes the other. This myth paints the artist as an inarticulate genius who can only communicate through his work. Yet history is full of artists who have thought deeply and written beautifully. And often this writing has been about how they see and what they do in the studio. Writing is as much a conceptualizing tool as it is an expressive one. Make writing a habitual part of your critique participation as well as your studio production. As strange as it may sound, writing can help you find out what you think.

Writing Before Speaking in Critique

Sometimes your instructor will set aside a quiet period at the beginning of the critique for everyone (including the instructor) to take time to look at the work and respond before any verbal exchange begins.

In an *open writing* session, you might spend some unstructured time before critique writing about the work in the room, each student choosing an order and length of time for considering each piece. In a *free writing* session, you will typically move in a group from work to work, writing for a timed interval in front of each piece before moving on to the next. *Free writing* is a specific technique that differs from open writing in that the writer becomes receptive to a stream-of-consciousness that is simultaneously recorded on the page. Variations include *free writing* about the entire body of work in a group critique as if it were an exhibition, or *free writing* while moving randomly around the room from work to work. Whether or not your instructor structures writing into a critique, you can always use it to collect and record your thoughts about the work in front of you.

How to Free Write

Free writing can be an effective warmup exercise. Here is how it is done. Get a pad of paper, set a timer for five minutes or so, and begin writing. Never let the pen come up from the paper. Don't stop to read what you have written. Keep moving, and if you run out of words, keep writing the last word you wrote over and over until you become unstuck. Five minutes is a long time to write without stopping to see what you have done. *Free writing* is writing without censoring yourself or stopping to compose, and it can yield surprising results.

Free writing is also a method that you might wish to explore outside of critique. For instance, try free writing every morning for two weeks or periodically in your studio.

EXERCISE I
Artist's Questions

Bring five to ten questions to the critique. Make photocopies for each of your classmates and the instructor.

Your questions will be handed out before the critique and answered during a quiet writing period before discussion.

Classmates, responses will be referred to in discussion of your work and returned to you at the end of the critique.

Thinking and Preparing *Artist's Questions*

Preparing your artist's questions. A few simple questions say a lot about what *you* want answered. Questions can address craft, options that you have wrestled with in the studio, artists that you are looking at, or any other issues that you want included in your critique discussion. For some students, the artist's questions do not come easily. Consider times when you were making the work and you were unsure whether to do this or that, and are still unsure whether you ended up with the best solution. Consider struggles you have had with craft. Do you already know that there are some technical problems with this work? Are these problems that you intend to resolve with time and experience?

Perhaps the questions are not just about craft or material choice, or composition or placement, but ideas that inform the work, which also are fair game. What kinds of investigations are going on in your work? What would you find helpful for your peers to address? Anything goes with what you choose to ask. Keep in mind that questions such as "Do you like it?" or "What do you think of this piece?" are not as helpful as those that focus the conversation. Remember that the more specific the questions the more helpful your answers will be.

Don't be afraid to solicit criticism! If you know that you still haven't mastered a technique, if you know that there are some problem areas in your work, if you know you are grappling with a controversial subject, you will be all the better for having actively addressed it in a dignified manner, rather than becoming sullen and defensive when your classmates bring it up.

Girl in a Box

On critique day, a student arrives carrying a medium size plastic sweater storage box. When it's her turn for critique, she takes the box out onto the sidewalk in front of the school and climbs inside. Miraculously, she is able to fold her 5'7" frame into the box and pull the lid on. She remains inside long enough for everyone in the critique group to get a little nervous. Is there enough air in there? Could she suffocate? At last she opens the lid and steps out, picks up the box, and walks away.

Her questions:

In the performance I was unsure whether I should have someone pick up the box that I had folded myself into and carry it away. What do you think?

Should I have used a wooden box instead of the clear plastic tub? Did it matter that I didn't make the box I was in? Would that have made the work more interesting for you?

I am not sure what the work is about for me. I just had a notion to do it. It seemed almost like a childhood memory, but also dangerous. What did it make you think of? Did it stir any memories?

Was it too long? Did you get bored? Were you ever worried about me?

Is the work less interesting because it is in front of the school? That is, everyone figures it was an art stunt. What if it were in a public place or even a discount store? Is it unethical to bring performances into people's lives in that way?

How do you see this work relating to Chris Burden? I like his work, but mine is not so hectic. What about a series of short performances?

Should I do a series of these? Does this seem lame compared to Brian's work, which took him the last three weeks to complete?

How could I have best documented this?

How would the work be different if I had titled it *Claustrophobia*? *Girl in a Box*? *14 minutes 32 seconds*?

EXERCISE 2
Five Categories

1. *Immediate Response*

What are your immediate responses? (These are uncensored, irrational, un-self-conscious impressions of the work; what you notice first, what stands out and how it affects you):

2. *Objective Description*

Objectively describe what is in front of you. Describe the work as if to someone who can't see it:

3. *Formal Matters*

Formal complaints and praise: Look hard at formal matters in play in the work: presentation, material choices, composition, draftsmanship, line quality, palette, placement in space, and so on:

4. *The Story It Tells*

This is the category that deals with *meaning*. Does the work tell a story? What is foregrounded? Is there a title? What associations does the work evoke? Try naming the work with a simple noun, then with a phrase.

5. *The Work in the World*

How does it connect to the rest of the world? With other works of art? With history?

Thinking and Preparing *Five Categories*

How to write about your immediate reactions to the work.

Immediate reactions are the uncensored, irrational, un-self-conscious initial impressions of the work. One way to begin is with a free association exercise. Write down the first single word or phrase that comes to mind when you look at the work. Another option is to free write for a minute in front of the work.

You might go immediately to a part of the work that has been intentionally foregrounded on a formal level, such as scale, color, material, or location in the space. Perhaps your first response to the work is irritation with the craft or the presentation. This is fair game and leads you right to the category of formal complaint. Conversely, if your first impressions of craft and presentation are positive, these lead to formal praise.

Your immediate reactions might take you to some specific image in the work. Name this image. In some works, immediate reactions take you directly to a narrative. Describe this narrative as you read it.

How to write about your formal complaints and acknowledgments.

Begin with careful looking. Write a very detailed description of what you see. Consider the work in front of you as a neutral object, not a work of art. Write your description as if you are trying to convey an image of the work to someone who cannot see it. Consider material, process (if evident), scale, texture, color, composition, proportion, and the relationship of the object (or objects) to the space.

Look hard at the formal matters at play, including the way the work has been made and presented, the material choices, composition, draftsmanship, palette, and placement in space.

Ask yourself if the work relies on realism. If so, assess the work's effectiveness. Consider craft by standards appropriate to the work. Ask yourself if the work relies on a specific craft or crafts. Name these. Is your formal assessment informed by a particular craft convention? (For example, is the canvas stretched without ripples and the corners neatly folded? Are the staples evenly placed? Is the stretcher bar square? Should it be? Is the sculpture well modeled? Is the aluminum casting without cracks and breaks? Is the video shot with appropriate lighting and edited without glitches? Does the armature have messy welds? Does the wooden display case have secure joints?)

Ways to approach the story it tells (meaning).
The story the work tells may be the trickiest part of the critique, because as we discussed earlier, *meaning* in a work of art is such a varied and multilayered thing. We can name the subject matter in the work and seek to interpret the message.

> *To help you think about it:*
>
> Make up a title for the work.
>
> Ask yourself what is foregrounded in the work. Is it some formal quality, such as color, scale, texture, composition, or relationship to site? Is there some specific imagery in the work? Name this imagery in as descriptive a language as possible.
>
> Ask yourself what associations the work evokes.
>
> Ask if the artist's identity affects your reading of the work. Think about the relation of authorship to meaning, and how who is telling the story can become part of the story.
>
> Also, consider if there is some information that the work refers to outside of itself. If this is the case, note whether this information is provided by way of common knowledge, additional text, verbal introduction, or some other means.

How to write about the work in the world.
This category addresses the work in context. Consider how the work being critiqued is *in conversation* with other contemporary artworks or with work from other historical periods. Consider what happens if the work being critiqued is taken out of the neutral space of the critique room (a white cube) and put somehow into the world. Ask yourself how its meaning is affected by its placement or location.

To look at the work in the context of contemporary art:

> Imagine that you are a curator and assembling a group exhibition with this work and a group of at least five other artists. Who would these other artists be and why? What might you call the exhibition?

Imagine that you are a co-curator in a large international exhibition project. You have been asked to place this work:

> With a work from a different century
> With a work from another country
> At a special site

Think about how this work would change if it were placed in a different site outside the critique room.

Think about how it might operate if it were not recognized as a work of art.

EXERCISE 3
Teasing Out a Story

First, Name the image in front of you with a single simple noun:

> *Girl*
> *Horse*
> *Landscape*
> *Still life*
> *Army footlocker*
> *Bicycle*

Now take the naming to another level so that you have a more descriptive phrase:

> *Video projected onto a wading pool filled with water, showing a girl shivering in a small pond with eyes covered.*

> *Billboard size poster showing a still life of fast-food burgers made into sushi.*

> *Three army footlockers. One open. Contents scattered and covered in shaving cream. Recorded sounds of drill sergeant screaming.*

> *Found bicycle modified with attached percussion instruments that are played when bike is ridden.*

EXERCISE 4
A Longer Story

The first step is naming. As described in the last exercise, begin with naming the imagery in the work through the selection of a simple noun:

girl

Take the naming to another level to produce a more descriptive phrase:

Video projected onto a wading pool filled with water, showing a girl shivering in a small pond with eyes covered.

We now try the following writing exercise:

The [*description of work here*] is [free write here and then edit].

Examples:

[The girl shivering in the shallow pond with her eyes covered] is [not getting out anytime soon. I think she doesn't mind so much. I think she might even live there. She will only uncover her eyes when we go away.]

[The girl in the pond] is [full of despair. Probably because she is cold and wet. I wish she would get out of that pond. I am tired of looking at this. I wish she would get out of that pond. I want something else to happen.]

[The girl in the pool] is [covering her eyes and counting to 100. When she opens them she won't find me.]

EXERCISE 5
Letter

Write a letter to a friend (imaginary or real), or to the instructor about another student's work that is being critiqued. The format can be open, but topics you may want to cover include:

A detailed observation of the work, written so that your friend can visualize the piece without the advantage of being in the room or seeing a photograph

Craft issues in the work

The story or a feeling in the work

How the work relates to other work you have seen

Give your letter to each student who was critiqued. The letters can be anonymous or signed with a pseudonym.

EXERCISE 6
Remote

Look carefully at the work. Write a letter to someone as if you are commissioning him or her to make an exact replica of the work. Imagery must be described in as specific a detail as possible.

Consider:
Shape
Color
Scale
Material

Include a stepwise detailed description of each step used in making the work.

EXERCISE 7
Art Publications

Do one of the following variations:

Random Draw: Before critique draw a name. This is your assignment for review. After the critique, write a review of the student's work whose name you drew and give to your instructor.

Reviewer's Choice: Select the work or works in the critique you wish to review. This variation is less democratic than *Random Draw,* as some works may not be reviewed at all and others may receive more than one review. This may reveal which works are most evocative.

Group Show: Write about the displayed work as if it were a group show, mentioning all the works in the *exhibition*. As a critic, you should identify common themes and/or formal affinities among the various works.

Interview: Interview another student in the class about the work shown in critique as well as other studio support work.

EXERCISE 8
Reporter in the Studio

Draw a name to determine which classmate you are assigned to interview. Visit that person's studio. Choose an option below:

Make an audio recording of the interview and transcribe it or isolate selected questions and type these up with the artist's answers.

Write an article from the interview.

Conduct a videotaped interview. Produce a short news segment.

EXERCISE 9
Drawing Exercises in Critique

1. *Simple Drawing:* No writing, no talking, just drawing. Respond to the work presented for critique by spending the day doing one drawing of each work. No discussion. Exchange drawings with your fellow students at the end of the day.

2. *Gesture:* Do one-minute gesture drawings of the sculpture from at least ten different positions in the room. Alternatively, do the same exercise using a brush and ink with a large sheet of paper.

3. *Footprint:* Draw the footprint of each of the works in the critique room. Produce a drawing for each work in response to the negative and positive space created.

4. *Positive and Negative Space:* Study each painting in the critique. Produce a drawing showing the positive and negative space in the painting.

5. *Viewpoints:* Circle each sculpture in the critique and draw its silhouette from four different viewpoints.

6. *Color Choices:* Photograph and using Photoshop change the color of one sculpture of choice. Draw sculpture and consider color change with paint, pencil, and so on.

7. *Construction Process:* Look carefully at the sculpture being critiqued. Draw a series of detailed sketches showing the process of making the work.

8. *Re-Construction:* Look carefully at the sculpture being critiqued. Draw the sculpture with alterations including additions, removals, reproductions, eliminations, elaborations, extensions, repositionings, and so on.

9. *Context*: Draw the sculpture in another spatial context. Draw the sculpture in a different historical context.

10. *Scale:* Draw the sculpture, but make it appear to be a very different scale.

EXERCISE 10
Translation Soundtrack

Draw Names. Produce or sample a soundtrack for the other students' work. In a class of fifteen, fifteen samples of sound/music will result. Put these on a CD and distribute to your classmates with an insert sheet of digital images of each work.

Everyone in the class assigns a soundtrack to each other's work. In a class of fifteen you will have fifteen samples, one for each classmate's presented work. Observe the range of responses to the same work.

EXERCISE 11
Space and Your Body Questionnaire

When did you experience the largest amount of space between you and another person?

When did you experience the largest amount of space between you and a small group of people with the rest of the world?

When did you experience the largest amount of space between yourself and someone you loved?

What image do you conjure when you think of the largest open space between you and another human being?

When did you experience the largest number of people near you? (A stadium, a city street, a protest march?)

What is the largest number of people you have ever been with/surrounded by?

What image do you conjure up when you think of a maximum density of people?

What is the smallest space you have ever been in alone?

What is the smallest space you have ever been in with other people? Write about this.

What image do you conjure up when you think of the smallest space you could imagine being in?

EXERCISE 12
Things to Think About (Worldview) Questionnaire

Do you think that art should serve a higher cause?

What higher cause?

Are you suspicious of such an idea?

Why or why not?

Do you think that the best art is art that *anyone* can understand?

Do you think that the best art is art that shows some talent or special technical skill in its making?

Do you think that art should serve some social function?

What do you think is the function of art in society?

Do you think that art should interface with the world?

How?

Do you think that art should be primarily a personal expression?

Do you think that art should be about itself?

Do you think artists are gifted people?

Can everyone be an artist?

Is everyone an artist?

How is everyone an artist?

If everyone is not an artist how do we know who is?

Where would you like your art being shown?

Where and how would you like your art to exist in the world?

Does the meaning of an artwork change if it is shown in a different culture?

At a different time?

Can a work of art be unethical and still be beautiful? Elaborate.

How do you define beauty?

Describe something you would define as beautiful.

Describe something you thought to be unethical.

FORMAL MATTERS IN PAINTING CHECKLIST

Look at the support:

What kind of material support is being used?

Is it a stretched canvas?

Is it a board or panel of some kind?

How deep are the sides?

What are the physical edges like?

Look at the shape:

Is it a rectangle?

A square?

Something else?

Look at the scale:

How big is the painting?

Bigger than you?

Smaller?

Look at the surface:

Was it painted with a knife?

A brush? What size? Were a variety of brushes used?

What kind of paint or other material was used?

Is there a mixture of materials on the surface?

Was paint poured or dripped? Something else? Scraped or sanded?

Is the paint thin or thick?

Is it even paint?

Is the surface smooth or rough?

Are there many thinly glazed layers of paint or one thin layer?

Have layers of thick paint been applied?

Can you see evidence of brush strokes? Evidence of the act of painting?

If so, have the brush strokes been made with speed?

Has the paint been glopped on?

Thinly patched in?

Are there other things on the surface? What are they made of?

Look at the ground:

Is there a ground that operates against a figure?

Is it dark or light?

Bright or earth-toned?

Look for a figure/ground relationship:

Is there a figure of some kind?

What is its relationship to the ground?

Is one more powerful than the other?

Do they feel balanced?

Are they connected (and separated) by a color relationship? By contrast of value? By line?

Can you tell which is figure and which is ground?

Do they ever merge?

Is there a lot of empty space?

Or does it feel dense?

Does the painting appear to be a window into an illusion?

Does your eye linger on the surface? Or pass through it?

Has a perspectival system been used?

Is it linear perspective?

Atmospheric perspective?

Has the illusion of volumetric space been achieved through something else?

Positioning of figures?

Overlapping?

Stark value relationships?

Relative scale?

Modeling of light and shadow?

Is the surface made of thin layers of transparent paint?

Is the smooth surface broken by thick brushmarks of paint?

Are they light in relation to a dark transparent ground?

Are there mechanically reproduced images?

If so, are they made of materials other than paint?

Look at the value relations:

Does the pictorial surface contain a wide range of values?

Is the painting mainly dark?

Mainly light?

Is there a strong contrast of value but little in between?

Does the painting seem to be organized by value relationships?

Are the values very close but the colors different?

Is volumetric space created through value?

Look at the color:

Is there a great contrast of hue or color?

Is the palette limited but saturation varies a lot?

Is the palette varied but there isn't much contrast of value?

Does the painting have a temperature? Very warm or very cool?

Is this a monochrome?

Is there a discernible color scheme? Triads? Tetrads? Compliments?

If so, have extension and saturation been considered?

Is the color balanced and harmonious?

Does it create an emotional or evocative space?

Is local color used?

Look at the edges within the picture plane:

Are the edges that connect areas hard edged?

Do they look like they were masked?

Have they been softly scumbled?

Are they hard to see?

Have they been done carefully?

Do they vibrate or shimmer?

Look at the composition:

Are shapes, lines, and forms related through juxtaposition (x,y axis)?

Or are they related by means of layered spatial planes (z axis)?

Is it an all-over composition?

If so, is it a repeated motif? A pattern of some kind?

Is the pattern organic or geometric?

Is there one dominant shape or form?

If so, is it angular or rounded?

How does it relate to the edges of the picture plane?

What is its relative scale to the whole picture plane?

How is it positioned?

Is it positioned in relation to other shapes or forms?

Is there a variety of shapes or forms?

If so, are they close in scale or varied?

Is there an emphasized contrast of scale between shapes and forms?

How are they organized? By color? Value? Line? Scale?

Is there a dominant mark or gesture?

Is there a linear understructure that you can see?

Can you detect an overall organization created by the parts?

What shape is it?

Is it stable or unstable?

Does it make the painting feel static or create a sense of movement?

FORMAL MATTERS IN SCULPTURE CHECKLIST

Is the sculpture a single object?

Dense?

Transparent?

Varied in character?

Full of negative spaces?

Forming a single interior space?

Is the sculpture a group of objects operating as a whole?

Are the units identical? Are the units varied?

Do they vary in scale?

Do they vary in color?

Are some built and some found?

Are the units connected physically?

> How is each unit physically connected to the other?

Are the units not connected physically, but visually?

> How does configuration/arrangement operate in this?

Are there areas of density and open space within the connected units?

What is the sculpture's relationship to the space around it in terms of orientation?

What is the position of the sculpture in the space?

> Is it in a corner or other intentional place?

Does the sculpture exhibit an extreme vertical orientation?

> How is this in operation?

Does the sculpture exhibit an extreme horizontal orientation?

> How is this in operation?

What is the sculpture's relationship to the space around it in terms of scale?

Is it a dense sculpture whose scale is less than 1 percent of the room?
Is it a dense sculpture whose scale is greater than 90 percent of the room?

Is it a sculpture whose volume is less than 1 percent of the room?

Is it a sculpture whose volume is greater than 90 percent of the room?

What is the sculpture's connection point with the space?

Is it placed directly on the floor?

> What are its footprints?

Is it placed on the wall?

How is it attached to the wall?

Is it suspended?

> By what means?
> At what distance from the floor?
> At what distance from the ceiling?

Is there a pedestal being used?
> What is its scale in relation to the sculpture?
>
> Out of what material is it made?

Is the sculpture operating as a field?

Is it a group of objects operating as a field?

Are these identical units?
> Are these studio manufactured units?
>
> Are these found manufactured units?
>
> Are these units from the "natural world"?

How do they relate in terms of color?

In terms of scale?
> Are these units varied?

What is the sculpture's:

Texture?

Level of transparency?

Lack of transparency?

Color?
> Is it local color (the color of the material or object as found)?
>
> Is it applied color?

Weight?

Volume?

Is it evident how the sculpture was made?

By what process?

FORMAL MATTERS IN TIME-BASED WORKS CHECKLIST

Think about time:

Is it what you would consider to be a short work?

Is it a long work?

Do you control the amount of time that you view/experience the work?

Does the work have a recognizable beginning, middle, and end?

Think about action:

Does most of the action occur in front of you?

How close is the action to your body?

Can you control how close the action is to your body?

Does the action affect your body?

Do you touch the work?

Do you have to move to experience the work?

Do you have a firsthand experience of the action in the work?

If you do not have a firsthand experience of the action in the work how is this communicated to you?

Think about movement:

Does the work move?

Can you see how?

Does it move all the time?

Can you control the movement in any way?

Think about palette and rhythm:

Does the work have a palette?

What is the palette?

Does the work have a rhythm?

Describe the rhythm.

Think about parts:

Is the work made of parts?

How are the parts connected? (These can range from transitions in film to fasteners in kinetic sculptures.)

Comment on how the following operates in the work:

Texture

Scale

Composition

Gesture

INDEX